HERTFORD

THROUGH TIME

Peter Ruffles, Jean Purkis
& Stephen Jeffery-Poulter

AMBERLEY PUBLISHING

Acknowledgements

The authors would like to thank Helen Giles, former Curator of Hertford Museum, and her successor Richard de Peyer, for their enthusiastic support for this project, as well as staff at the museum who have helped in the preparation and distribution of materials. Particular thanks to the late George L. Blake for use of the Grammar School photograph, and to Robin Southgate for the Thieves' Lane photograph. We are also grateful to Sonia Cousins, Manager of the Hertford Town & Tourist Information Centre for her input and assistance.

First published 2011

Amberley Publishing
The Hill, Stroud,
Gloucestershire, GL5 4EP
www.amberley-books.com

Copyright © Peter Ruffles, Jean Purkis
& Stephen Jeffery-Poulter, 2011

The right of Peter Ruffles, Jean Purkis & Stephen Jeffery-Poulter to be identified as the Authors of this work has been asserted in accordance with the Copyrights, Designs and Patents Act 1988.

ISBN 978 1 4456 0272 1

British Library Cataloguing in Publication Data.

A catalogue record for this book is available from the British Library.

Typeset in 9.5pt on 12pt Celeste.
Typesetting by Amberley Publishing.
Printed in the UK.

Introduction

Trying hard not to sound like a retired teacher, I seem to spend a lot of time asking people to look carefully at our town today, in 2011. Hertford is a beautiful place. We are fortunate to be here and to be able to welcome visitors and friends with pride. Visitors *always* remind us how fortunate we are to live in Hertford.

Yet there have been many recent changes, and not all have been for the better. The reader cannot fail to notice the destructive impact of the relief road. Widely felt at the west end of the town, St Andrew Street and Hertingfordbury Road, where so many ancient landmarks were lost, as well as opposite Christ's Hospital, in the back gardens of Fore Street, and the south side at All Saints' Churchyard and Castle Street, as the new route charged its way through people's homes and even their final resting places. It has damaged parts of our town in order to protect others.

It is to the yester-year photographs in this volume that I really draw your eye. A few images taken from very early twentieth-century glass plate slides have not been published before. Modern technology can now transfer to computer views what otherwise could only be imagined today. Notice the detail of all the archive pictures. Some of today's shots (no fault of Stephen Jeffery-Poulter, the fine photographer) are bleak in comparison, and a few could not be successfully taken at the exact spot of the earlier frame. But you *will* see more trees today; more space (usually created for the motor car); and more colour. So we can enjoy both the 'then' and the 'now'.

Browsers of the book will expect a quick history of the County Town. It is still a small, almost 'self-sufficient' town, the administrative capital of a County, which has had an identity as 'The Shire of Hertford' for one thousand years.

Perhaps the deer, or harts, had taken water at a clearing in the forest where a track crossed the Lea, maybe it was 'Herut's Ford'. Whatever. Water supply was key to the place which became Hertford. Water has continued to be 'key' through the ages of our local history. We are a confluence town. The Rib, the Beane, the Mimram, all flow in to meet the waters of the great River Lea. The Lea has come all the way from Luton.

After forest clearance, the arable land around the Hertford basin, or saucer, led to the creation of the Hertford and Ware staple industry of brewing. Mills and maltings created the skyline, and the characteristic town smell. It may have also helped the population to live with the other characteristic aroma, to do with sanitation, as the population became more dense.

Hertford's civic side grew up because of the Castle. The river gave access to foe and friend alike – but defences were necessary against foes – and so came the Castle and the subsequent administration for town and county.

Surrounding wealthy landowners, made sure that we stayed a small town. They were glad of the thriving market and the busy shopkeepers nearby – but at Balls Park, Panshanger, Ware Park in Bengeo, and the like, there were to be no homes for the common people and thus no town expansion. The wet green fingers of the incoming river valleys were also unsuitable for homes until very modern times.

Many of those earlier constraints do still apply today, so we've grown slowly and that has been a great benefit. We are still small enough to know each other and to know the whole town, the whole community, Hertford, in which we live.

Our volume has just a few of the vast collection of scenes from the town's past which are available for all to browse, easily, at Hertford Museum's picture kiosk. Jean Purkis has contributed the serious stuff; the anecdotes and assertions I can be blamed for.

Peter Ruffles

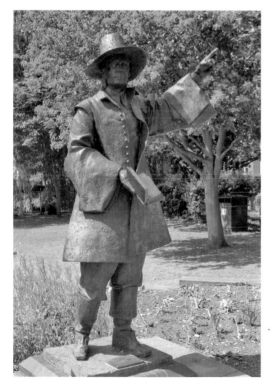

Samuel Stone, born in Hertford in 1607, was one of the first boys to be educated at Hales Free Grammar School, now Richard Hale School. Cambridge and ordination followed and in 1633 he set sail for the New World where he founded Hartford, Connecticut. He died there in 1663. His statue was put up in 2000 through the interest of Keith Marshall of Marshall's Furniture (previously Fordham's) in Fore Street.

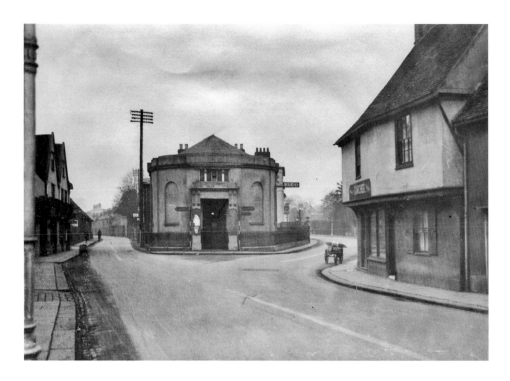

The Ebenezer Strict Baptist Chapel

Looking west from St Andrew Street, the Ebenezer Strict Baptist Chapel was positioned centrally between Hertingfordbury Road, left, and North Road, right, from 1773–1966. This junction became hazardous for motor vehicles where North Road traffic gave way to traffic from Hertingfordbury Road due to restricted vision. In 1967 a new meeting house, or chapel, was built on the north side of North Road when road reconfiguration saw the demise of the old building. Shops and shopping finished, to all intents and purposes at this point.

HETFM 6037.323

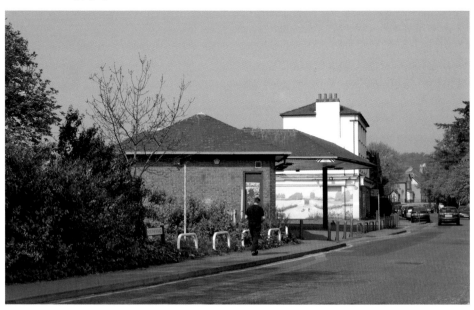

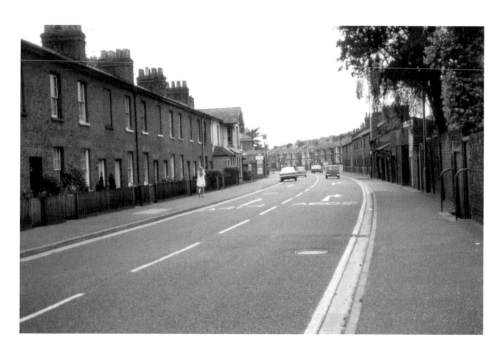

Hertingfordbury Road looking west

Hertingfordbury Road looking west, before road widening swept away the cottages on the left, built in the 1830s. On the right are the back garden walls of the grand 1824 North Crescent. The cottages, and villas beyond, survive. Peter Ruffles' grandfather was born in 1870 in one of the cottages on the right, but the family crossed the road to a bigger house, just out of the picture to the left, next to St Andrew's School and the present-day Wareham's Lane.

PR00400

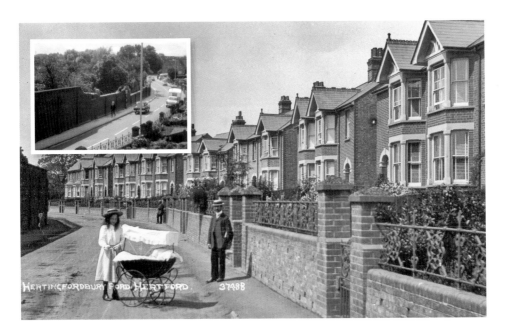

Hertingfordbury Road Villas

The newly-completed row of Hertingfordbury Road villas, *c.* 1912. The first to be built were those nearest the camera. The airing of bedrooms was important.

Inset: The castle kitchen garden wall latterly sheltered gardens rented from Lord Salisbury. Note the demolition men on the wall. In the subsequent road widening a number of the villas lost a portion of their front gardens, and most gardens are now car parks. Riversmeet houses and flats now occupy the 'fruit trees and summerhouse' allotment gardeners' land. Alan Flack from Campfield Road is walking into town, cautiously!

 HETFM 2833.01 (Inset: PR00327)

Thieves' Lane

Thieves' Lane was once a single track road leading up from Hertingfordbury Village to the Welwyn Road, where it made a crossroad with Cut-throat Lane which went on to Bramfield Road. Beyond the central tree the Sele School is under construction.

PR00919 [A gift from Robin Southgate]

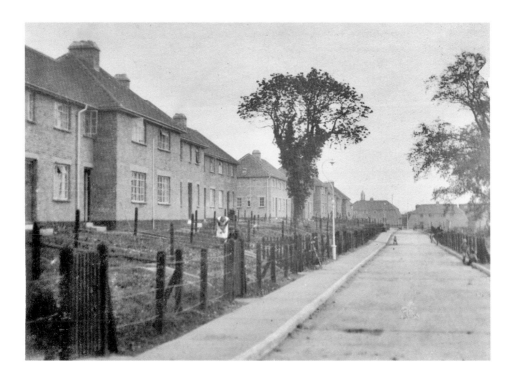

Ashley Road

Ashley Road, part of the Hertingfordbury Road Estate, was built in the early 1930s by Hertford Borough Council. Some came from London, and farther afield to occupy these bright new homes with indoor lavatories and bathrooms. Most families were known to each other, however, through moving here (and to Horns Mill, Bengeo and Foxholes), from properties cleared from the town centre yards and Bircherley Green (where Waitrose and Boots trade today). We're told that in 1945 only one house in five or six, in Hertford, had a bathroom. The Borough Council served people well.

HETFM 6037.118

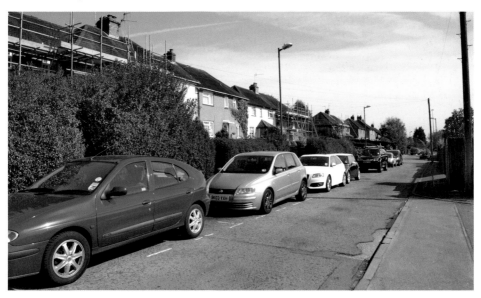

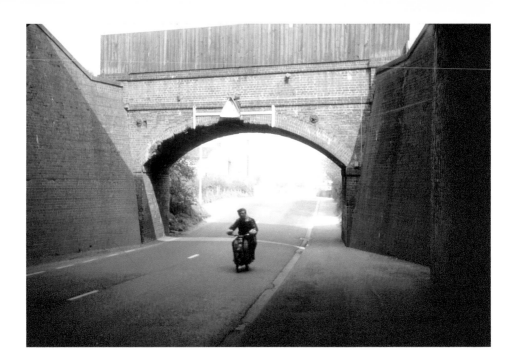

Hertingfordbury Road Railway Bridge

The Hertingfordbury Road railway bridge, which carried the 1858 line from Cowbridge Station to Welwyn Junction via Hertingfordbury and Cole Green Stations, ceased operations in 1966. Too low for increasing lorry sizes, the left side of the bridge has been visibly damaged. It was dismantled in 1967. The remaining long tunnel-like bridge, which takes today's commuters to Moorgate, casts its shadow towards the original line to Kings Cross and its red brick bridge. Freddie Hopkins is on the Honda 50.

 PR00753

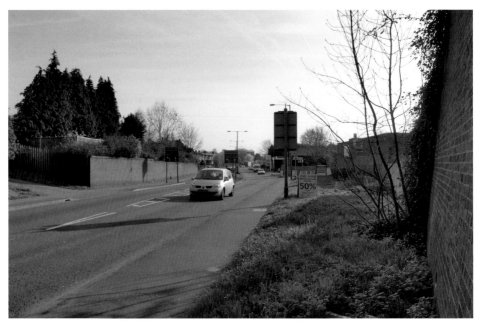

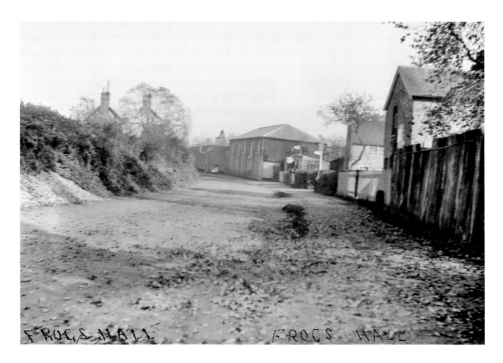

Hertingfordbury Road looking east

Hertingfordbury Road looking east from near the 1858 line railway bridge in 1903. On the right of this marvellous picture are Frogs Hall cottages and a blacksmith's with petrol pump. Centre is a barn-like building of the late eighteenth century, formerly an equipment store for the Hertford Castle Kitchen Garden. Frogs Hall cottages remain today and the Esso Garage has 'continuing use rights' to operate a petrol service station, from Mr Will Wackett's petrol pump era!

HrtMus An 113121

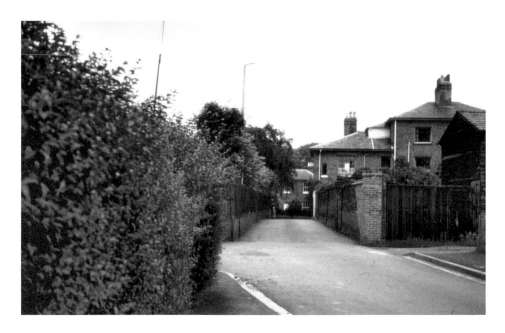

Cross Lane towards North Road

Cross Lane, looking towards North Road. Middle left is the 1910, St Andrew's Rectory garden and on the right, the ancient garden wall of No. 41 North Road, or Crescent. The house dates from 1824 and the wall from at least the 1700s. Facing us, in North Road is North Lodge, No. 10, where Mr Barker kept Hertford's Ambulance in the 1940s and 50s. A stream, in a channel in the cellar, flowed under the house to emerge through a pipe into the Sele Millstream at the bottom of the garden. Later, it was the home of St Andrew's Church Curates and the Revd Harry Tasker Evans. Cross Lane was widened in the mid 1960s. The lower picture shows the large 1844 'Rockleigh' on the left, now replaced by modern town houses. St Andrew's Rectory garden has been much reduced.

PR00004 PR00537

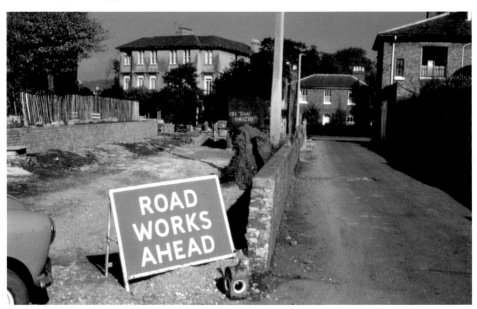

The Widening of Cross Lane

Detail of the road works involved in the widening of Cross Lane.

Inset: The 'step houses' were on the corner of Cross Lane and numbered 40–46 Hertingfordbury Road. Built in 1824, they lasted until 1965, when they were removed in the widening of Cross Lane. They were big homes for big Victorian families. Robin Walker's timber-boarded 48 Hertingfordbury Road was actually in Cross Lane. The roof and chimneys in the distance on the left are of nos 39 and 41 North Crescent. The roof on the extreme right, No. 36 Hertingfordbury Road, is still present as the last of the row of twelve cottages.

 PR00765 (Inset: PR00006)

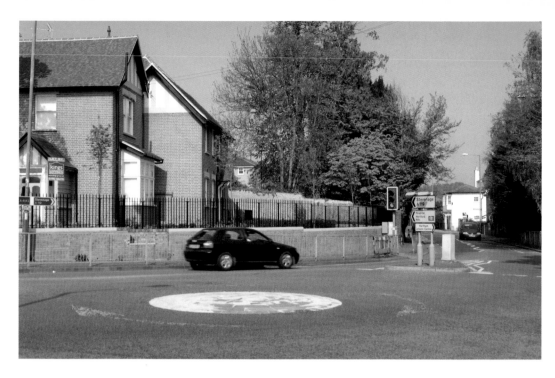

Cross Lane and North Road Corner

The corner of Cross Lane and North Road *c.* 1900, before 'Froome', Garratt the Miller's house, which became St Andrew's Rectory, was built. This may have been the garden gate and wall of Sele Lodge. On the extreme right is the Sele Mill House.

Hrt Mus An 113062

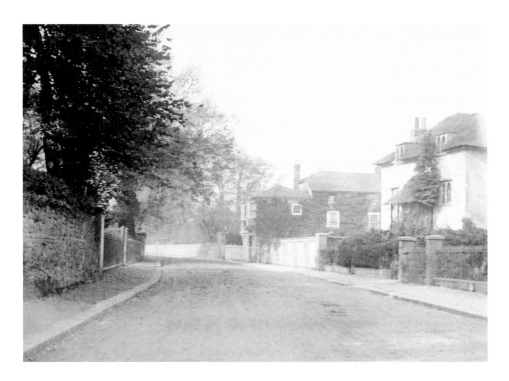

North Road towards Sele Mill

North Road, looking towards the Sele Mill and Mill House, right. The thatched house, nearer the camera, was divided into four dwellings and was damaged by a Zeppelin bomb, which fell near the mill gate in 1915. The thatched roof of the porch was subsequently replaced by corrugated iron. Home to the Walford family and other Hertford's long-time residents, this well-known house was demolished in the 1950s. Sele Mill ceased to function in the 1980s, and has been converted into residential units.

Hrt Mus An 108041

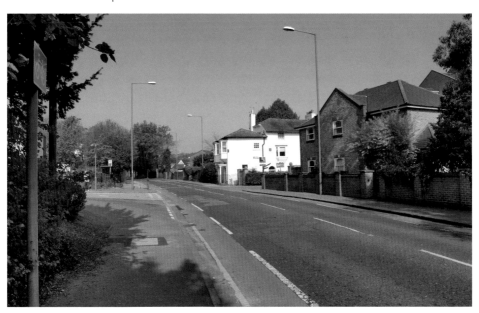

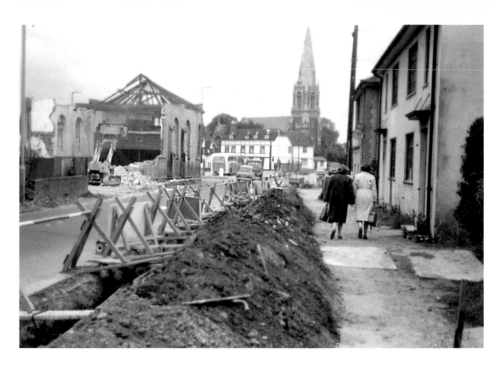

Demolition of the Old Ebenezer Chapel

In 1773, the Ebenezer Strict Baptist meetings started in Bulls Barn on the apex of a piece of triangular land between Hertingfordbury and North Roads. A meeting house was put up in 1786. This is the building you see as it was demolished for the relief road in 1966. Centre is Cawthorne House and St Andrew's Church. Dan Dye's coach is just passing nos 58 and 60, St Andrew Street. Nellie and Daisy Ansell from Chelmsford Road, and earlier Bircherley Green, are heading off to work as the familiar landscape changes.

PR00049

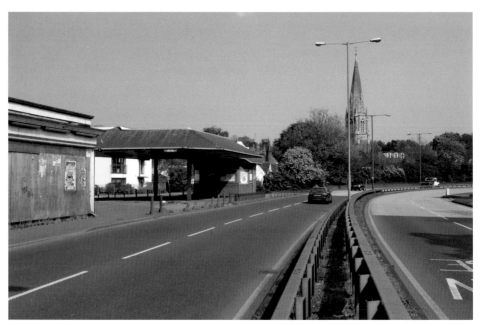

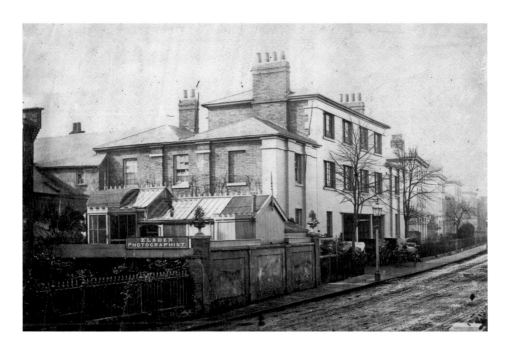

Arthur Elsden, Photographist

Behind the Ebenezer Strict Baptist Meeting House, and in front of McMullens Coachworks, was the home and business of Arthur Elsden, 'photographist' from 1857. He and his son, Arthur Vincent, provided the majority of Hertford town archive photographs held by Hertford Museum and the County Record Office. The premises were built in 1824 on land owned by the Dimsdale family. The first of the 'Regency Terrace of North Crescent' will later become the showroom and repair entrance to Sessions, later Waters' Garage. The four chimneys, on the stack at the middle of the picture, remain.

HETFM 6506.159

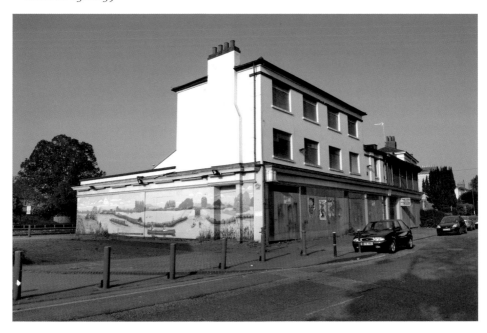

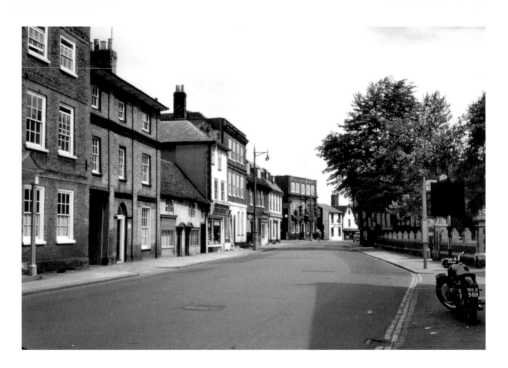

St Andrew Street looking east

Two cottages, nos 46 and 48, have disappeared to be replaced by a three bay jettied, modern 1970s structure where roof lights are evidently preferred to the 'vernacular' dormers, now Clover Kitchens. London Transport's bus stop has given way to Interlink and gone are the stone supports for the chains along St Andrew's Church wall. As in all modern pictures, cars make their presence felt, but the street scene is otherwise relatively unchanged.

PR00678

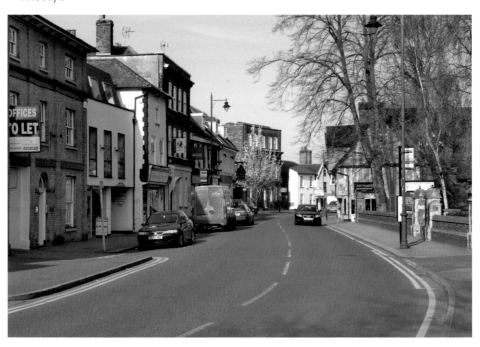

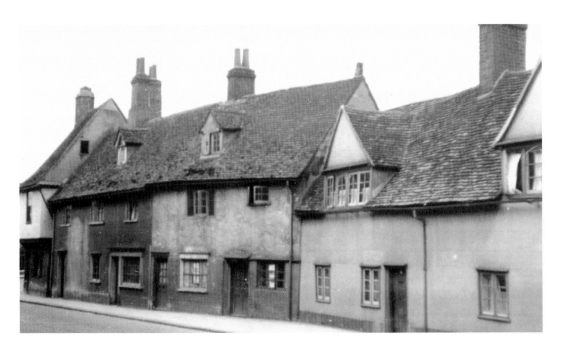

Numbers 58 and 60 St Andrew Street

These two cottages survived the mass destruction of ancient property at the west end of St Andrew Street in the 1960s. The demolition took place to make way for the relief road. The present view reveals the small car park belonging to the now closed Waters Garage, and the 2004 'Ebe' apartment block built on the site of the replacement 1967 Ebenezer Meeting House. The cottages have 'catslide' rear roofs, and originally had a 'pre-chimney' smoke hole. They are believed to be fifteenth century or earlier.

HETFM 6037.110

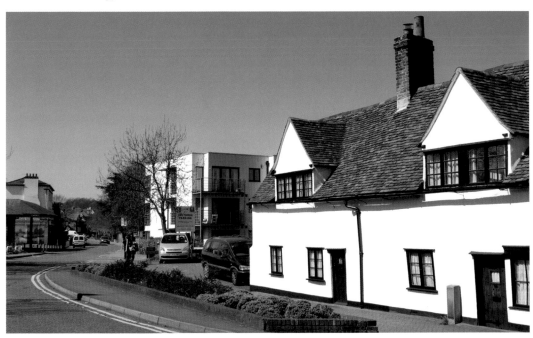

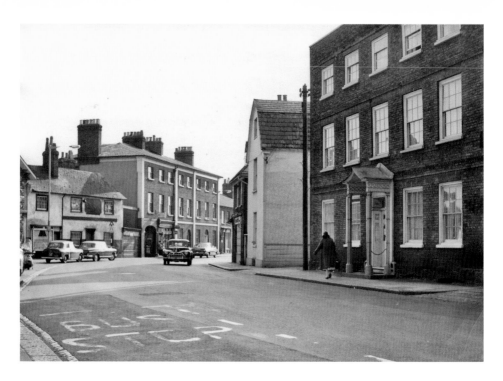

St Andrew Street west

This is a fine view of St Andrew Street west, before the removal of property on the left for the Gascoyne Way. The public house is the Red Lion, the visible archway leads to Pavitt's or Hattam's Yard, and then comes Ginn's, the builders. Cecil House on the right remains, with its distinctive and much valued 'Strawberry Hill' porch. In the early twentieth century, this was the first home in Hertford of Dr Burnett Smith and his novelist wife, Annie S. Swan.

HETFM 1993.12.1.37

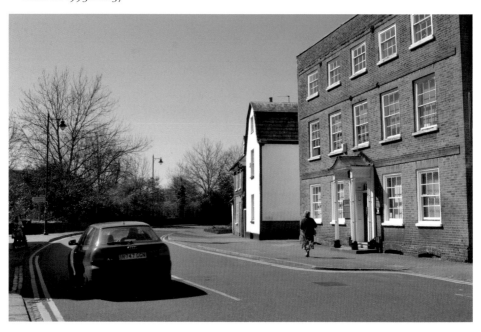

**Pavitts or Hattams Yard,
St Andrew Street**
The far end of Pavitts, or
Hattams Yard, resembles a
country lane, but two members
of the Hattam family have
walked under an archway from
St Andrew Street past several
typical yard cottages. Today,
Hattam's Yard can be found at
the other side of Gascoyne Way.
The cottages numbered 26
by 1831.
 PR00082

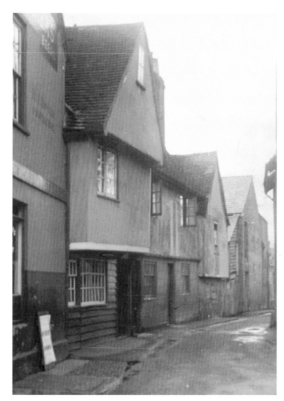

Brewhouse Lane, St Andrew Street
Brewhouse Lane, from St Andrew Street.
The jettied buildings on the left are
part of the old Three Tuns public house
(now Baan Thitiya), and old cottages,
now long gone. In the 1990s, Brewhouse
Lane became a 'highly desirable' new,
but traditionally designed, small, tucked-
away place to live.
 HETFM 6037.108

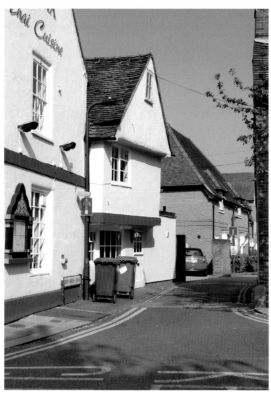

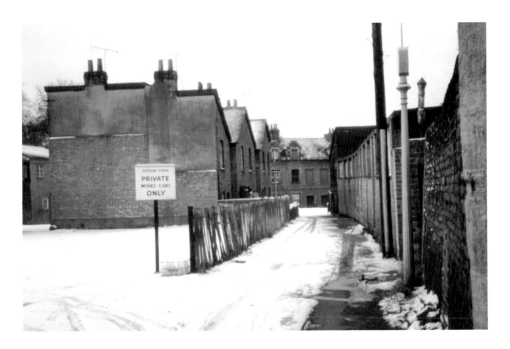

Into Brewhouse Lane

The late eighteenth and early nineteenth-century houses of Brewhouse Lane were larger and of better quality than the average Hertford courts and yards dwellings erected for election purposes and were inhabited until the later 1960s. The name Brewhouse Lane is thought to be associated with John Moses Carter's brewery, there by 1822. His maltings were behind the Three Tuns, and the hairdresser's Belles & Shears, formerly the Little Bell public house. In the seventeenth century, there was the bell foundry of John Oldfield, after which the Little Bell was named.

PR00636

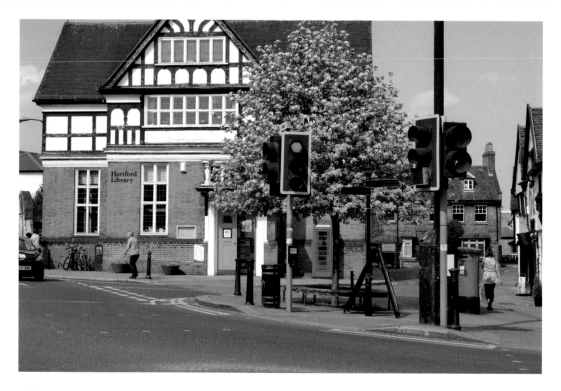

Old Cross

This lively, sun drenched image, with which Jean is much taken, must have been photographed in about 1887. The building had been, from 1850, the newspaper office of Pollard's Hertfordshire Guardian, which moved to Railway Street when the site was purchased for the Borough Library and Art School, and opened in 1889. Mr Raw, presumably, took a short lease for his second-hand shop with stabling. The lane at the side leads to the house of William Baker, brewer, whose Hope Brewery was incorporated into McMullens in 1920.

Hrt Mus WDB 093302

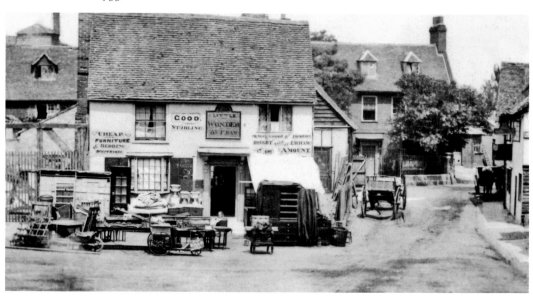

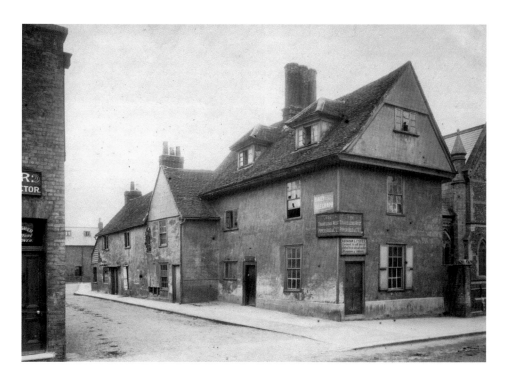

Cowbridge

The Travellers' Rest, in Cowbridge, at the Dimsdale Street corner. Little is known of this fine, ancient building, but a trick chair for the unsuspecting, also called the Travellers' Rest, is a feature of Hertford Castle tours and is rumoured to have come from a town hostelry, maybe this one. Older Hertford people will remember Mrs Foster's wet fish shop here, then Fred Phipps' Motor Cycles, followed by Hill's Motor Cycles. Bill Munt, hairdresser, and Pingey Cormack's fish and chips, were in the cottages into Dimsdale Street.

HETFM 6036.242

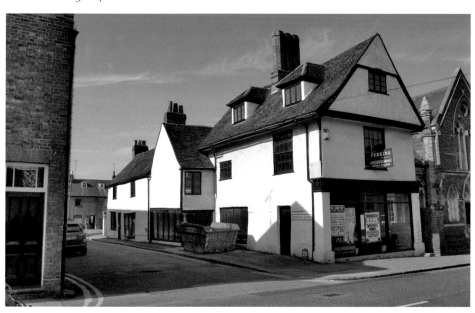

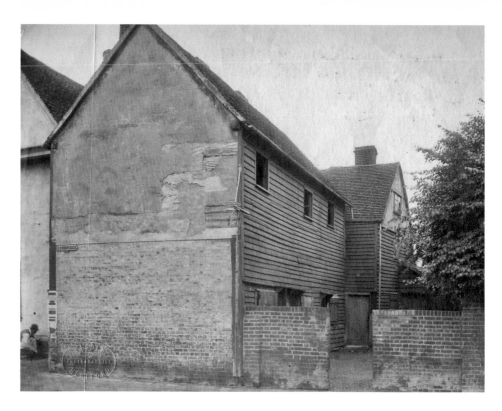

Cowbridge Hall to come

Next to the Travellers' Rest in Cowbridge was a barn-like building, once a baker's, which was demolished for the Cowbridge Hall, built 1891. This was the hall of the Congregational Church, which was originally on the next site as the Independent Chapel from the 1780s, and rebuilt in 1863.

HETFM 6036.69

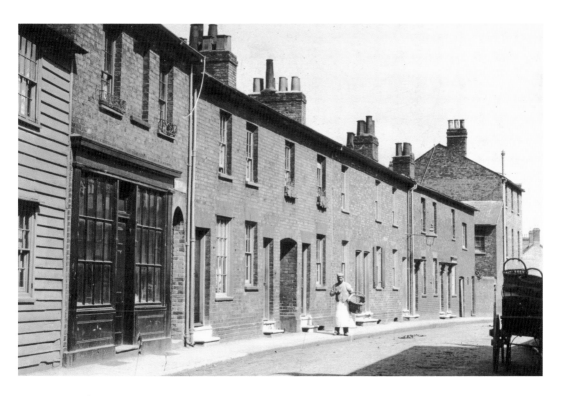

Port Vale

Port Vale, looking towards the junction with Port Hill and Cowbridge. Bridens, a well-known local bakery was here, and one of its delivery carts can be seen to the right. The building of Port Vale, by George Darby, commenced *c.* 1830 with George Street. These well built houses are all much sought after.

HETFM 2835.515

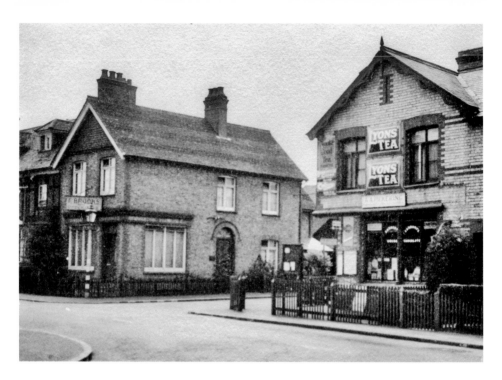

The Corner of Bengeo and Tower Streets

Tower Street was so named because it originally led to Bengeo Water Tower, which stood where the Parish Hall, Duncombe Road, stands today. The building on the left was built as a coffee or temperance tavern in 1879 by landowner, William Green. On the right is the busy general store, remembered as Pickerings for many years.

HETFM 6037.44

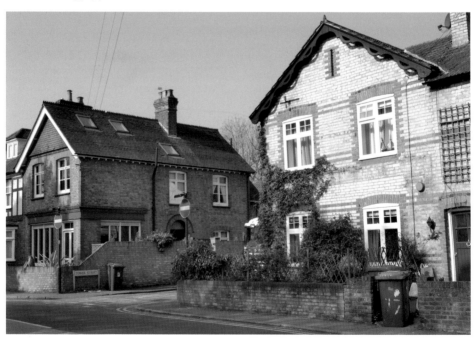

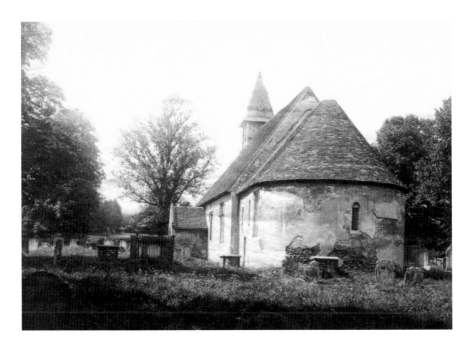

St Leonard's Church, Bengeo

It is described by Pevsner as '… the rare example of a virtually intact Norman village church; nave and chancel with apse …' There is evidence of an anchorite's cell and a legend that French King John, a prisoner (but with many freedoms) at Hertford Castle received a blessing from this holy man in 1359. After Holy Trinity Church was built in 1855, to accommodate the needs of a growing Bengeo, St Leonard's slowly decayed. It was saved from demolition by the energies of Gerard Gosselin, of nearby Bengeo Hall, and a group of enthusiasts, starting in the 1880s. Today, the church is still used for services, concerts, and is open to visitors on summer weekend afternoons.

HETFM 6370.1.69

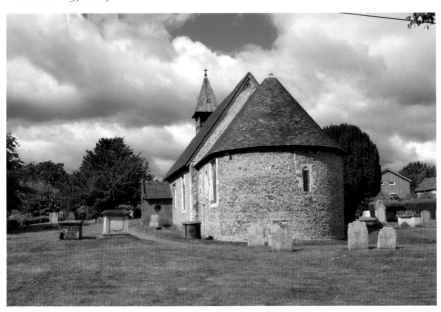

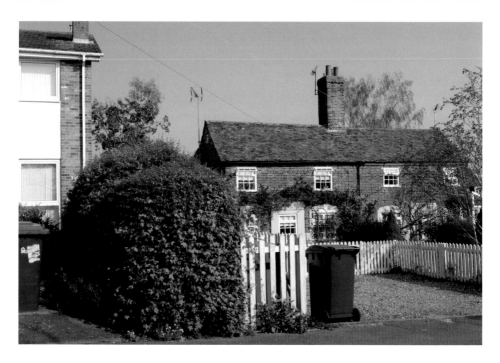

Almshouses opposite St Leonard's Church, Bengeo

Bengeo 'began' as two settlements well seperated. There was the hamlet at the top, far end of Bengeo Street near the Greyhound public house, and there was the Globe, an ancient hostelry. There was also this area, where grand houses were built near the original village church of St Leonard. Two of these five almshouses remain.

HETFM.6037.149

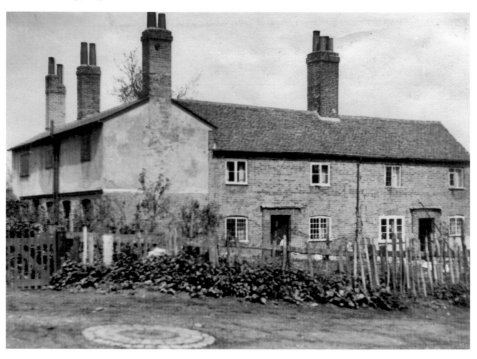

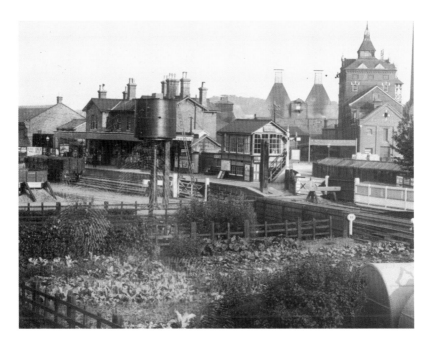

The Old Great Northern Station

As an 'anorak', this is Peter's favourite shot. It is the old Great Northern Station (which preceded Hertford North, which didn't open until 1924). The line, a single track, ran behind Port Vale houses to Beane Road and continued at a lower level towards Hertford North, before falling away down towards Hertingfordbury Station and on to Hatfield and the main line to London. What a lovely country station scene this is. Taken from the rise of the crown of the bridge approaching from Port Hill and Bengeo, this view can't be achieved today. Gone are the railway allotments, the single branch line signals, the water tower, the sidings, the signal box, and the engine shed. But McMullens' Victorian Brewery and Sainsbury's remain! The photograph may have been *c.* 1920.

HETFM 2833.005

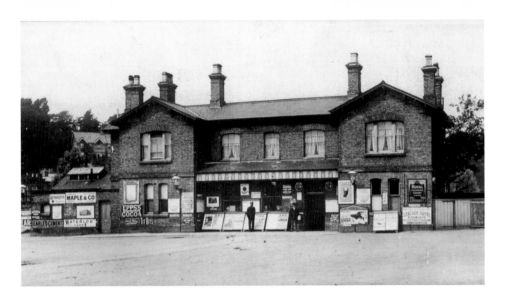

Station Approach
Down Hartham Lane, the left fork past Ekins afforded this view. The road was sensibly called Station Approach, and the 1858 Great Northern Station, not quite as impressive as the 1888 Hertford East of the Great Eastern Railway, nevertheless looks ready and welcoming for travellers to North London and Kings Cross.

HETFM 2833.005

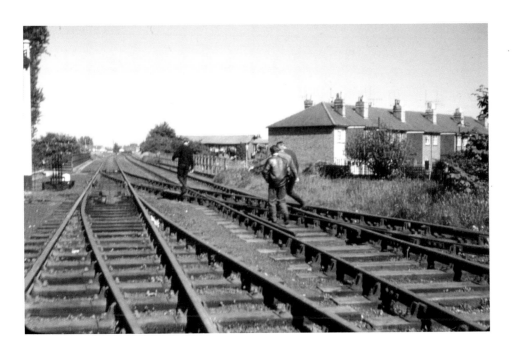

Railway Lines, Now No Longer

No passenger services ever went east from the old Great Northern (Cowbridge) Station, but the Great Northern had a line which ran into the Hertford industrial area of Mead Lane. From that line a link was eventually made to join Great Eastern metals on the Ware side of Hertford East station. Here, in 1960, Peter Stagg, and Malcolm Clayton and friends nipped across the tracks to the fun fair on Hartham near Frampton Street on Folly Island. The tracks were still used at the time for goods (mostly coal) shunting yards. Now the reason for the long thin car park is apparent!

PR00335

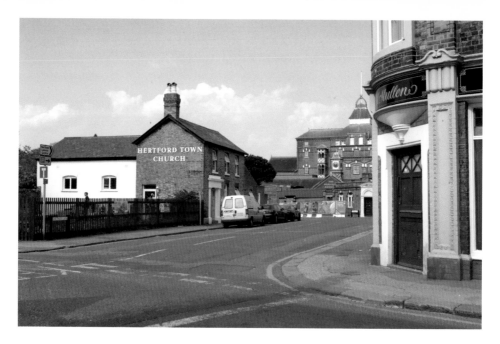

McMullens'

The 1891 brewery, centre, was situated between Station Approach and Hartham Lane. The turret clock, probably from an earlier building, is an 1829 example by Moores' of Clerkenwell. This brewery, a listed building, closed in 2008 and was sold to Sainsbury's. Taken in the early 1960s, the lower shot reminds older residents of the remarkable and still undeveloped plot on the left. Then, it was the allotment at the heart of the town. Chrysanths, soft fruit and vegetables were cultivated between pipes of Black Beauty tobacco by Dick Farrow. Grammar School 'old boys' will recognise Latin master, Richard Gander, making his way home to Bullocks Lane under the umbrella, after playing the organ for Sunday Service at Christ Church, Port Vale.

PR00133

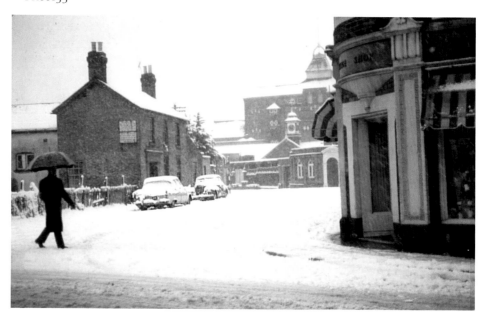

Old Cross

Little real change in the buildings, but their uses have changed. Gunner's, tobacconist and confectioner (sweets!), becomes Antiques; Farnham's, the newsagent's (the centre of Peter Ruffles' teenage universe), remains. Next was The Ship; Miss Chapman, dressmaker; Eddie Palmer, baker (cakes only, no bread); the Co-op chemist with its cast iron spiral stair and the Co-op butcher; then Barber's Seeds Merchants, on the corner. What a fine row of Hertford-typical dormer windows!

HETFM 6037.399 PR00825

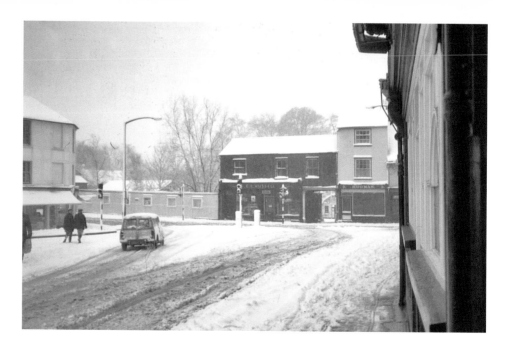

Mill Bridge

When the V1 Flying Bomb, or 'doodle-bug', fell in the waters of the Lea at Mill Bridge in 1944, it left us a bomb-site in the town centre for many years. At this point, the façades of the Wickham's Brewery had just been taken down and replaced with a hoarding bearing advert boards. The first traffic lights, here, gave way to a mini roundabout before traffic lights returned. They give a green right of way to an early Mini Traveller, and snow covers the temporary asbestos roof of Russell's, the chemist. Before the doodle-bug, the building had an additional floor. Mr George Durrant had been chemist before Russells' and his Nissen hut, Durrant Hall, St John Ambulance, the Dolls' Hospital, and so on, can be seen through the arch.

PR00089

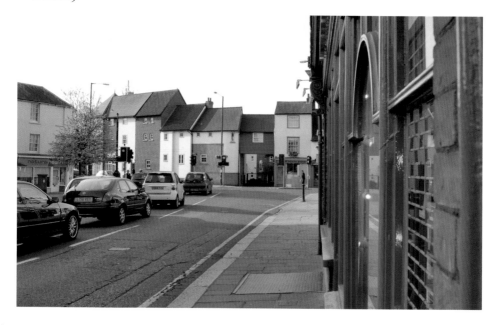

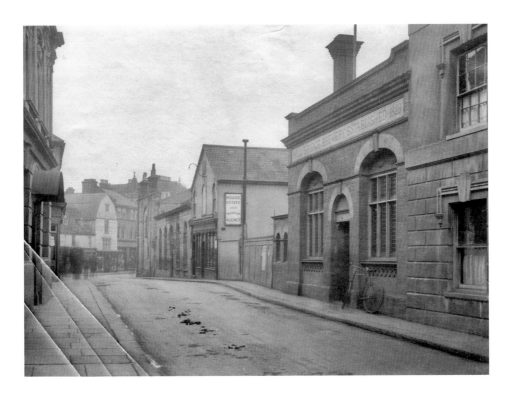

Wickham's Brewery

Mill Bridge was not widened until around 1927. In this archive picture, from the right, are Wickham's Brewery, established in 1828, behind its house and tap, the bridge parapet, and Ilott's Town Mill. Buildings on the immediate left were demolished in the widening. Just beyond the parapet on the left side, and out of the picture, was the Toll House, before freedom from toll in 1893.

HETFM 6037.12

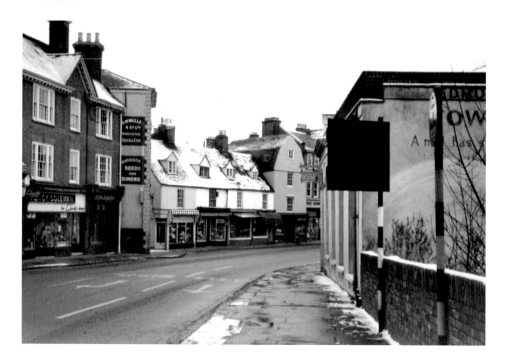

Mill Bridge towards the Wash

Apart from the absence of the Town Mill, right, today's scene remains much the same. McMullen's Seed Warehouse, behind the McMullen Seed Shop, has become Hertford Museum's large artefact store. Percy Coleman's Shoe Shop has given way to Colormax and the range of small shops, including the long-stay 'Bouquet' owned by Doris Paddick, have now changed hands several times. The distinctive Mansard roof once sheltered Randall's, the saddle maker's business. Interestingly, the odd angle of McMullen's Seed shop (it now sells pizza and kebab) guides the eye; it shows the original shop front line before the bridge widening.

PR00615

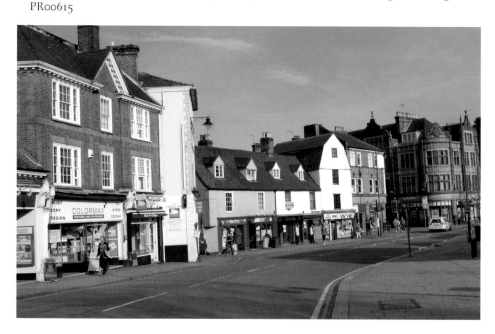

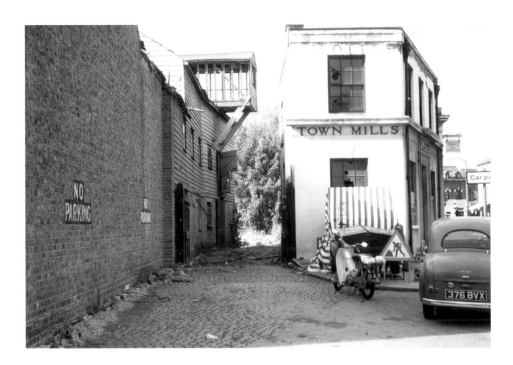

The Town Mill

The distant buildings, common to both photographs, are accommodating The Sugar Hut, today on Old Cross. The 1960s photographer stood outside the Castle Cinema – approximately where the entrance to Hertford Theatre is today and looked towards Old Cross and St Andrew Street. 417 UAR is the photographer's Honda 50.

 PR00967

Inset: Statue of Samuel Stone (see page 4).

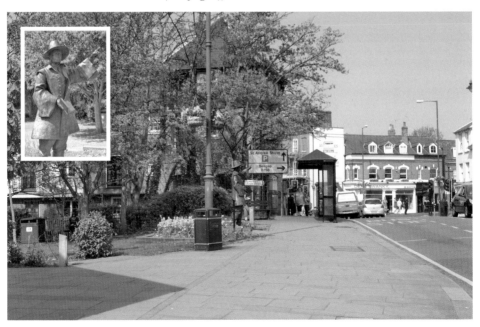

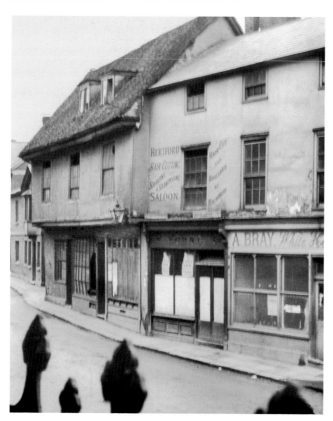

Before the Castle Gates

This range of buildings was removed in 1910, to open up views of the castle curtain walls. At the end of the following year, Hertford Borough Council signed a lease to take over Hertford Castle as their offices. In 1912, the present castle gateway from The Wash was cut through the curtain wall and new gates were presented to the town by O. H. McMullen. Brays, seen right, was a dairy and at the extreme left, proud of the building line, were the premises of John Briant, bell-founder and clockmaker extraordinary. His house survived until the mid 1970s. Present in both pictures is part of Wetherspoons, which has a pediment and a legend on it proclaiming its former function as a Workingmen's Conservative and Unionist Club.

Hrt Mus WDB 093101

Maidenhead Street in the 1970s

Before pedestrianisation: Bartons, the bakers, Drury's clock, and the arrival of Hertford's first supermarket, Fine Fare. Miss Bunyan of Russell Street is approaching, having just passed Mrs Mabel White and a companion. Maidenhead Street was so named after the Maidenhead Inn, which stood about where Woolworths came to be in the 1930s.

PR00610

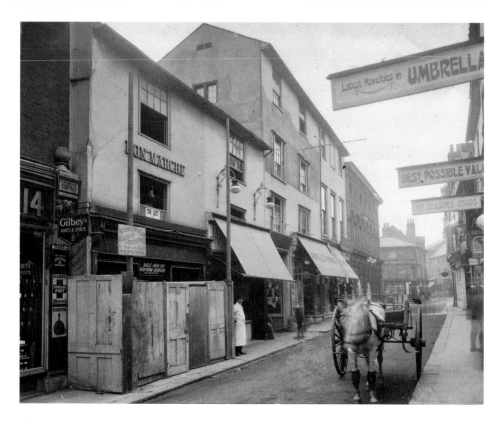

Maidenhead Street *c.* 1900

The tall buildings, centre, Arnold Thomas, draper, and Hilton's boot shop were burned down in 1917 and their one storey successors were replaced by the Edinburgh Woollen Mill at the end of the twentieth century. The original building was, until the 1760s, the Glove and Dolphin, a former inn with an assembly room. Whilst the Shire Hall was being built from 1769–72, it is said that the courts and the council meetings were held in the former inn's assembly room. No one-way rules for the horse and cart in the picture.

 HETFM 6036.275

The Old Coffee House Inn

This hostelry stood at the corner of Maidenhead Street and Honey Lane, until it was replaced by Montague Burton's men's outfitters, in 1939. The wooden pilasters of this undervalued, seventeenth-century, or earlier building, have fortunately, been preserved at Hertford Museum. Burton's former shop, which accommodates billiards and snooker on its first floor, has become a shoe shop at ground level.

Hrt Mus WDB 163501

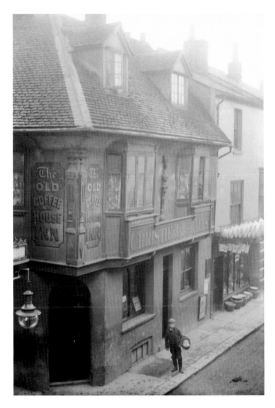

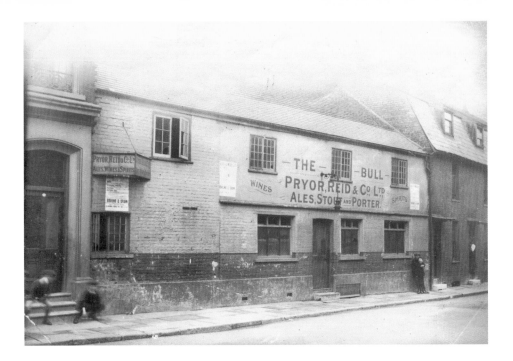

The Bull

The Bull was originally the malting, and then the tap, of a galleried Bull Inn, formerly the Prince's Arms, which stretched almost from the corner of Maidenhead Street to No. 17 Bull Plain. The inn was demolished in 1857 and the block of shops and offices built, which, in more recent past, included Webbs, newsagent's, then Chappell's toy shop, Geall's Café, Canvas Holidays and the Prince Regent, and now the Stonehouse. The Bull tap was left as a public house and the premises are now occupied by In Depth, also a Geall family concern, and Hertford Cameras, previously Green's, a grocer's shop.

HETFM 6036.143

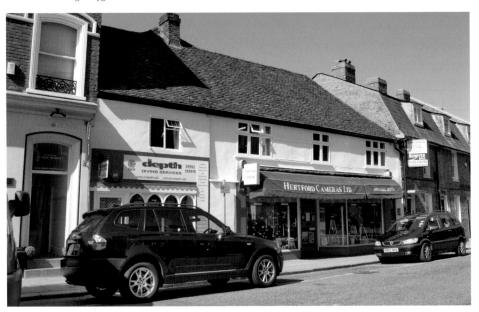

The Arcade

The 1930s Arcade closed in 1980 when the east side of Bull Plain was re-built. It's a detail, but the worn step (worn chiefly by countrymen's boots, probably) of Mr Ellis' tobacconist and fancy goods shop must have taken many years of wearing. The local market town offered several specialist tobacconist's to shoppers, Shepherd's in Fore Street; Miss Law's on Old Cross; as well as sweet and cigarette shops. The oil-converted-to-gas lamp over the door had been hit by a lorry just before the shot was taken. It was the last pre-First World War independent shop light in the town.

PR00091

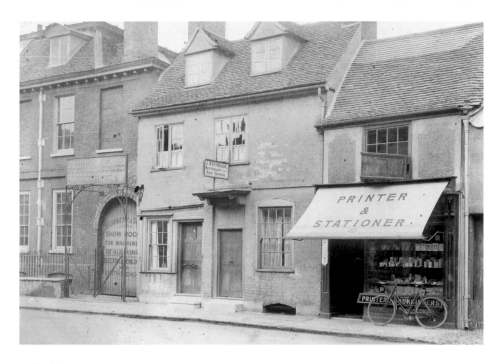

Bull Plain

Left, Dimsdale House, originally two unfinished cottages transformed into an elegant Queen Anne style house *c.* 1703 by Dr John Dimsdale. Its likely demise, along with other Bull Plain properties, was one of the *raisons d'être* for the founding of the Hertford Civic Society in 1969. It was saved and restored as Beadle House. It's just possible that items from Hertford Museum's taxidermy collection were prepared at Mr Seymour's.

HETFM 6036.232

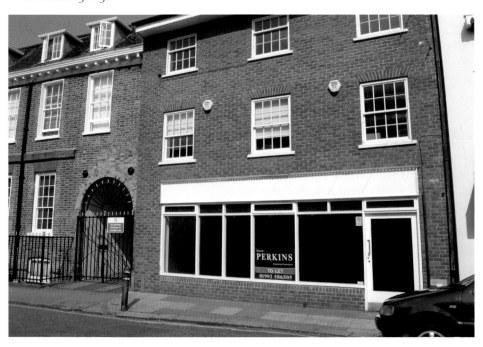

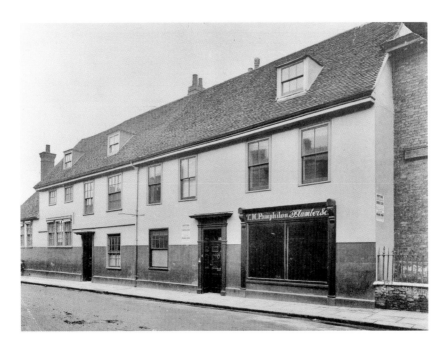

Hertford Museum

No. 18 Bull Plain, together with No. 20, was built in around 1610. The picture shows the premises between 1893 and 1913, when it was the home and business of Thomas Pamphilon, plumber and Captain of the Borough Fire Brigade. Miss Joan Pamphilon, a descendent of the family, still lives in Hertford. No. 18 was purchased in 1913 for a museum by R. T. and W. F. Andrews, architect and builder brothers in a family firm. They had started a collection in their business premises at 56 Fore Street in 1903 and needed a building they could set aside for their collection and open to the public, which was duly done in 1914. Over the last 100 years many improvements were made to the museum, but in 2009–10 it closed for a major overhaul and is now one of the most up-to-date and user-friendly small museums in the country.

HETFM 6036.140

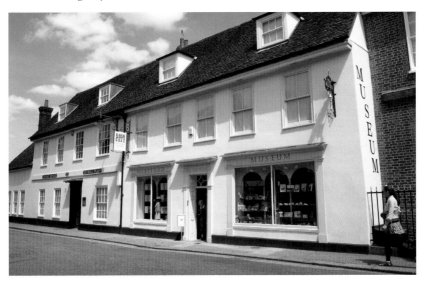

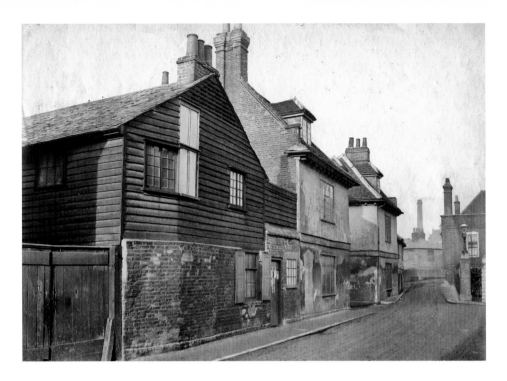

Zeppelin Raid

On the evening of 13 October 1915, a Zeppelin L16 dropped 14 High Explosive bombs on Hertford, a third of which fell outside the Conservative Club, Lombard House, Bull Plain, killing 6 people and injuring others. The substantial house on the left was 'Waterside', an ancient property the original garden of which went down to the water's edge but then provided the land for the cottages still in existence. Waterside was demolished after being badly damaged in the raid and the Bull Plain Clinic was built on its site in the 1930s.

HETFM 6036.74 and 6036.24

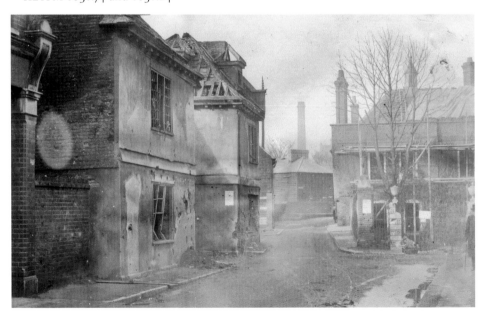

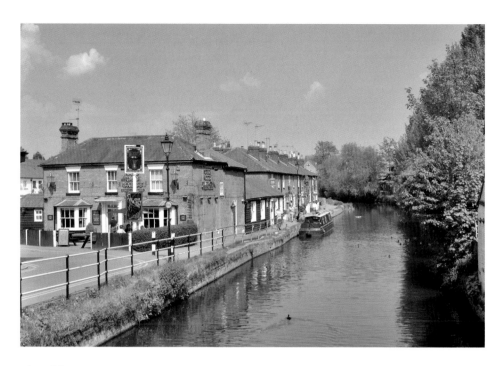

The Old Barge

The Lea Navigation in 1760s provided a fine highway as far as the head of navigation at the basin, just upstream from the view below. The industrial buildings – timber, grain and fuel stores – on the right bear witness to the importance of the river for business. There are no bow windows on the artisan homes in riverside and the Barge Inn is a simple neighbourhood pub. We now travel along the towpath briefly, before returning to Bull Plain and the town centre.

PR00108

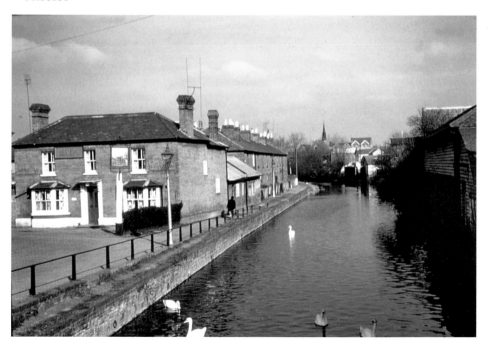

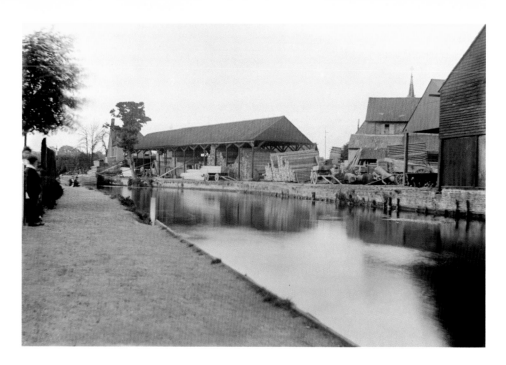

The Lea and Timber Yard

The wood yard in the later nineteenth century belonged to R. T. and W. F. Andrews, founders of Hertford Museum. It occupied the site of Hertford Priory, dissolved in 1537, after which it became decayed. A new church of St John was built in 1629 nearby, but was short-lived owing to it being annexed in 1640 to All Saints, and then dismantled soon after. This section of the Lea Navigation, known as the New Cut, was originally a millstream for the Priory's Licker or Dicker Mill, before the mill's removal farther downstream in the 1630s.

Hrt Mus An 113021

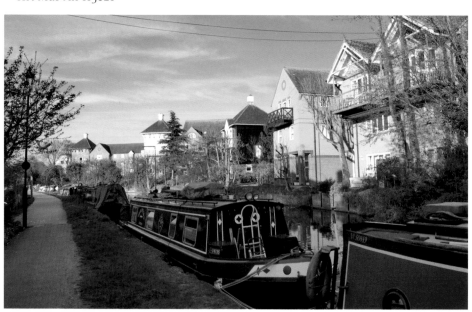

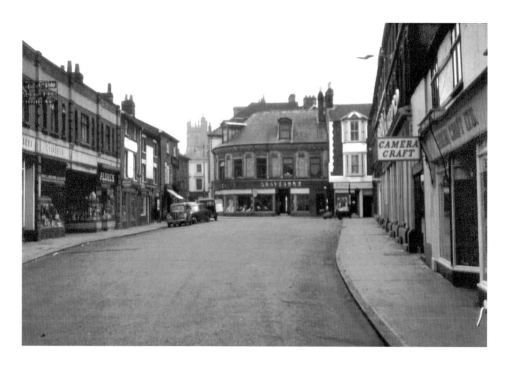

Bull Plain looking South

Lady Desborough fell while walking alone (i.e. without a maid) in Bull Plain on 11 May 1943. She lived at Panshanger and was a famous 'society hostess' and friend to leading national politicians. The fall marked the start of her final illness. The photograph in 1964 must have been taken on a bank holiday. Graveson's impressive shop front dates from 1891 although a draper's shop had been on the site for nearly 100 years before that.

PR00229

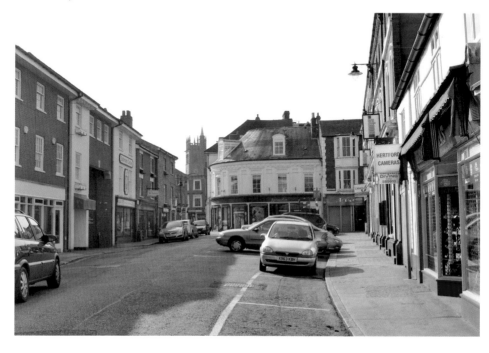

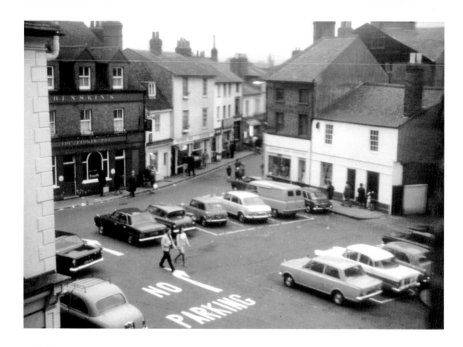

Salisbury Square

This picture was taken from the Shire Hall in the 1960s. Before 1925 two former public houses, the Red Cow, facing Railway Street, and the Vine, facing towards Fore Street, stood back-to-back in this spot, then part of Market Place. After their removal, the square was used as a car park, until heritage paving, and the coming of the Hertford Civic Society's Fountain, a gift from Mrs Medlock, in 1994. The 'fountain', or 'water feature', commemorates the confluence of Hertford's four rivers. The market stalls pitch here on Saturdays. Railway Street leads off bottom left to right, so named in 1844 because it was the most direct through town route to Hertford's first railway station. The street was previously Back Street.

PR00220

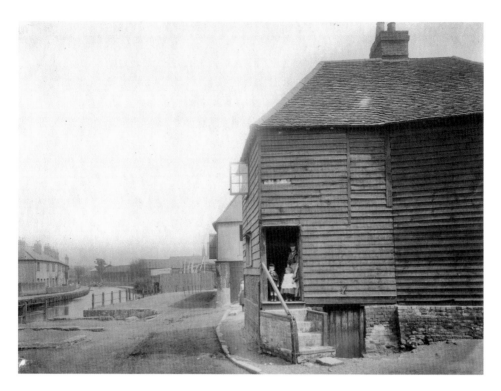

Dye's Dipping Place

We journey down Green Street (Bircherley Green Street) to Dye's Dipping Place, which was a small descent into the Lea where horses and ponies could drink. The Dye family were chimney sweeps who lived in Bircherley Green during the nineteenth century. The dipping place has long gone but its location, behind Waitrose, can still be found.

HETFM 6036.222

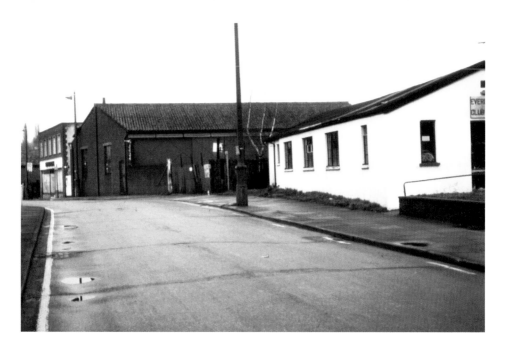

Evergreen Club, Bircherley Street

Buses travel in and out of the bus station today via Bircherley Street (Butcherley Street). On the site of the modern sheltered accommodation, Bircherley Court, had been The Evergreen Club, founded by former mayor, Dan Dye. Mr Dye's haulage and coach garage would have been beside the Greenline 715 bus stop and Botsford's builders' shop. Far left is the Salvation Army Citadel, a building of 1859, which formerly housed The Ragged School, founded in 1855, in a disused chapel in Railway Street.

PR00235

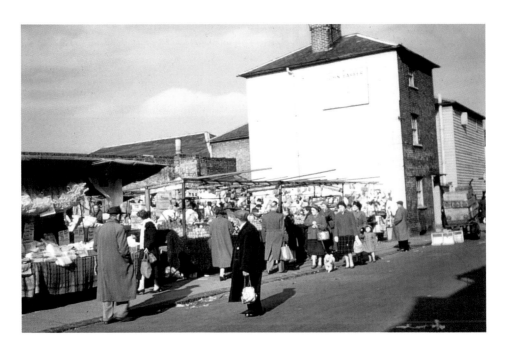

Railway Street Market

Mrs Lowe, from Sele Road, with her poodle and her daughter Carol, walk where Halfords is today by the taxi rank. They've just passed Barber's grain store, which was on the Lloyds Bank corner of Bircherley Street. The 1960s picture is silent, but Carol and Mrs Lowe, Wilf Ashcroft, and others pictured, would have heard the calls of the Banana King, the China King, and so on.

PR00105

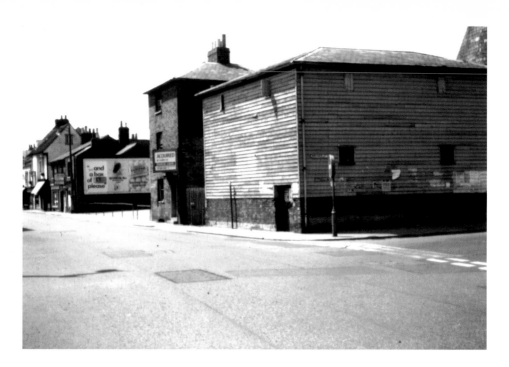

Bircherley Street Corner

Now Lloyds Bank, previously Barber's grain store, which was said to have been requisitioned in the Second World War as an ammunitions store. It was behind this corner, in a yard, that the Borough Fire Brigade kept their engine and equipment in the later nineteenth century, before the first fire station was built in 1901 in Mill Road.

PR00240

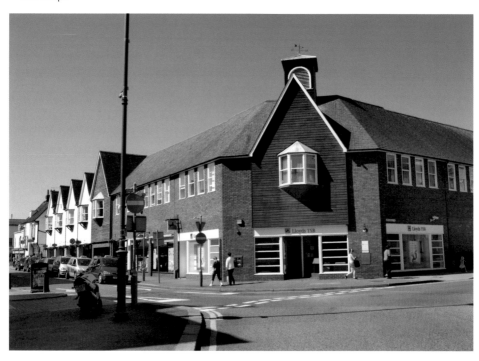

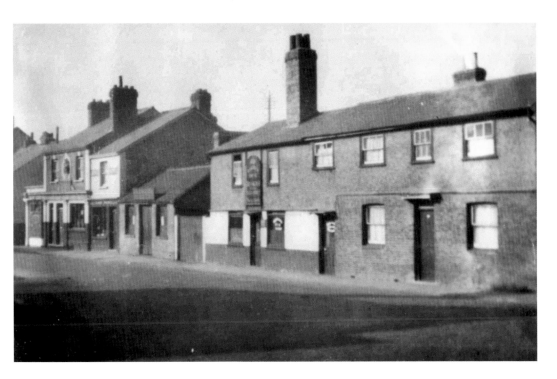

Warren Place

The heavy chimney stack on the Warren House public house betrays its antiquity. A maltings lid gives a reminder of the past typical, skyline around Hertford and Ware – and there is the memory for some, of the blacksmiths, the Hertford Town Football Social Club Office, and the Lion's Head public house. Just off both shots to the left were the neighbouring fish and chip shops, Donoghues, and Tovells.

HETFM 6037.328

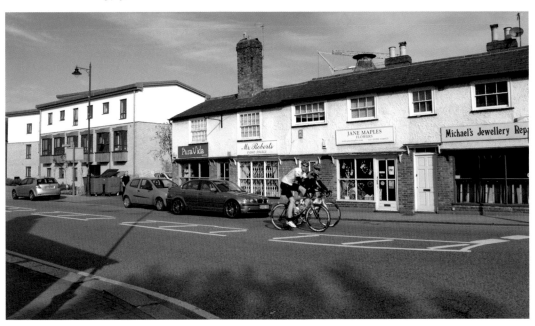

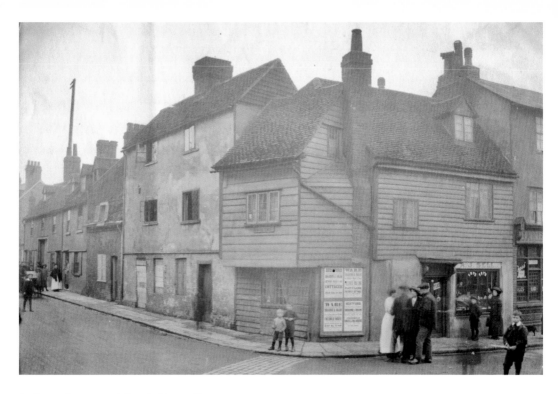

Railway Street and South Street Corner

The west side of South Street from Railway Street is shown before the road widening in the 1890s, and again before the First World War. South Street had been called Sow Lane in even earlier times, explaining the oddity of the name for a road which doesn't really play a significant and consequential part in a traveller's southward journey.

HETFM 6036.334

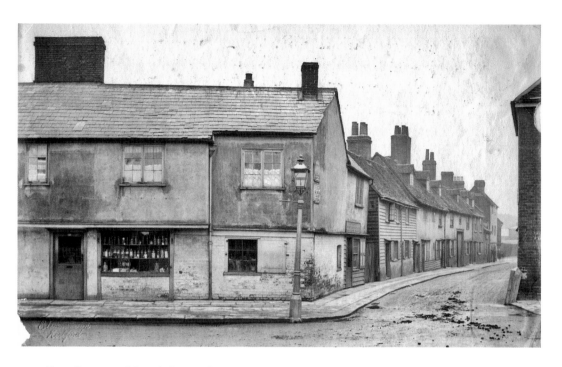

Fore Street and South Street Corner

The west side of South Street from Fore Street, shown again, before the road widening. In the 1830s and 1840s, Peter Ruffles' great, great grandfather, James George, carpenter, lived in South Street next to his wheelwright brother, Henry. Their houses would have faced Young's Brewery, behind the Blue Coat Boy. Margaret Hart's 'Aladdin's cave' of a store was built, with its belvedere turret, for shepherds, plumbers and decorators.

HETFM 6036.58

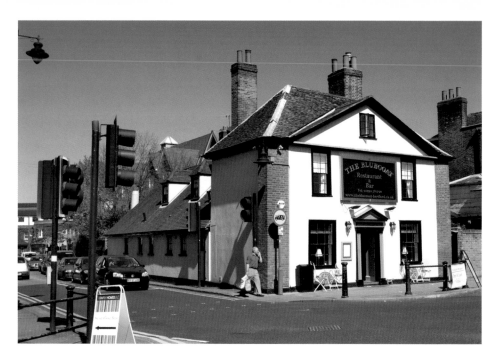

Blue Coat Boy, Fore Street

The Blue Boy sign is an image of a Christ's Hospital 'Blue'. Owned by Benskins in the early 1970s, it was sold in 1979, became a free house, and renamed the Sportsman. It was once the tap of Youngs, established 1754, whose brewery was behind the public house until 1897 when it was sold to Christ's Hospital and the site was used to expand the school. The pub's extensive make-over as a restaurant was completed in 2010 with a variation in its name – The Bluecoat.

PR00163

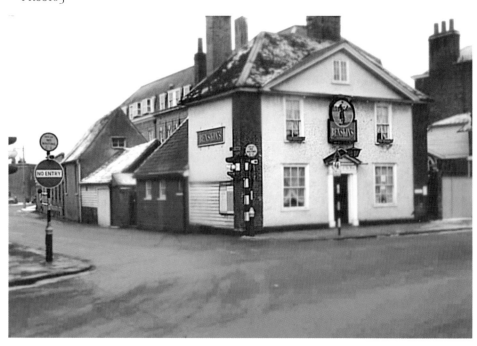

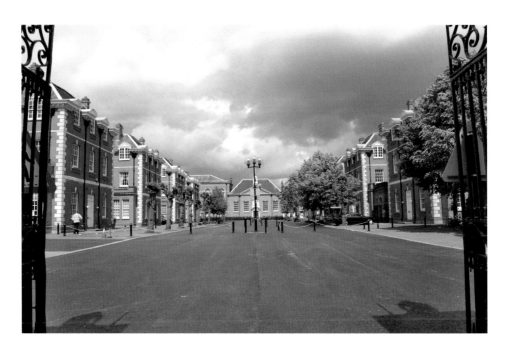

Christ's Hospital

This was a branch of the London charity school founded in 1553, Newgate Street, the City. The Hertford School started in 1682, at Meager's Farm, Fore Street. New buildings were begun in 1689, but as money ran out, the premises closed as a school and was let to tenants. It re-opened in 1704. The fine buildings facing Fore Street were built by 1778. Early cottage accommodation for children was replaced by large blocks facing the central avenue in 1906. In 1985, the girls moved to join the boys, who had departed for Horsham in 1902. Offices and sheltered accommodation took over the site. The 1824 clock was restored in 2010 and its host building, refaced in 1906, is one of the original 1690s structures, built as the Writing School.

 HETFM 6182.23

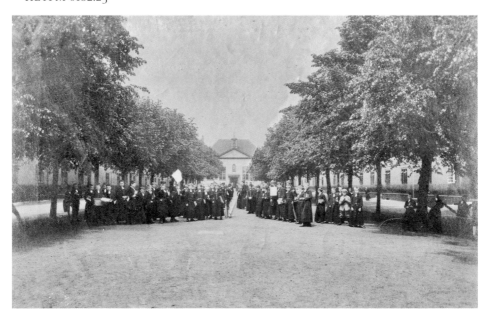

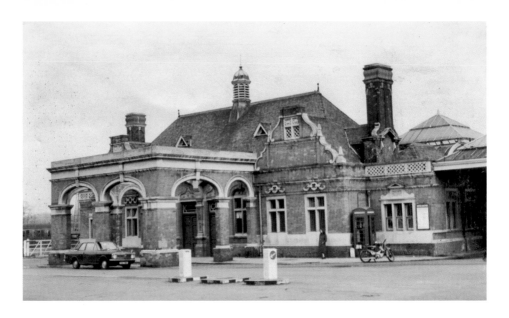

Hertford East

This station was built in 1888, a replacement for a smaller station 300 yards farther east, itself built in 1843 when the line was opened. The new station was designed by W. N. Ashbee 'in the Free Renaissance style ... with Dutch Gables on the Mill Road frontage' (Hertford Civic Society 2006). With James Wilson, Ashbee also designed Norwich Thorpe Station and the old Liverpool Street. Hertford East has two large *porte-cochères* where passengers could transfer from vehicle to station under cover. It is Grade II listed.

HETFM 2006.34.22

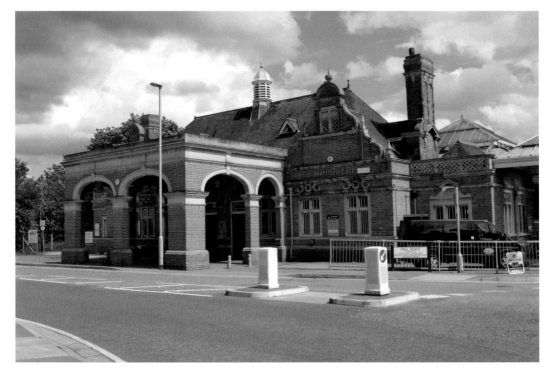

Plough Corner

The Plough Inn (centre) had been rebuilt in 1935 and was demolished in 1990. It was formerly called the World's End from at least 1690 to 1775 and gave its name to the area. This ancient hostelry was popular with bell-ringers and All Saints' Vestrymen in the eighteenth century. Here, in the 1960 shot, boy scouts *look* like boy scouts. The art deco fronted county cinema is still projecting new releases, and the former town houses, Georgian style, await demolition so that the London Road roundabout has full capacity for twenty-first-century traffic.

 PR00167

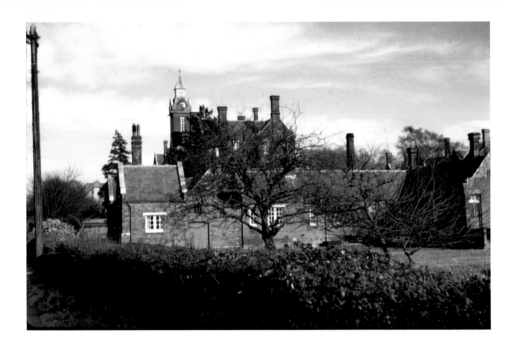

Kingsmead School, Ware Road

This building of 1869, near the junction of Ware Road and Stanstead Road (Gallows Hill) was built as a workhouse for the Union, replacing a smaller accommodation *c.* 1830. In 1919, paupers were moved to Ware and the building became Kingsmead School, catering to slow learners. In 1968–69 the school was closed and eventually taken down and replaced by a police station in 1972. Although the police moved out in 2007, to Hale Road, their building still stands. Today's photograph is taken from a different angle to include the former police station. John Briant's workhouse clock, made originally for Ware St Mary in 1809, found its way to All Saints' Church in 1969, after the Gascoyne Way had forged through the churchyard.

PR00255

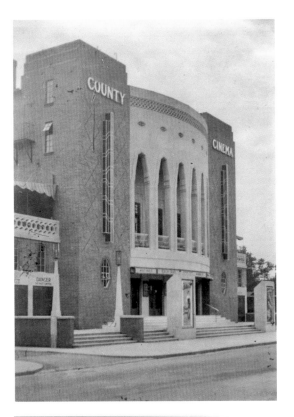

The County Cinema, Ware Road

Described as a luxury cinema showing 70 per cent British films, the county cinema was built on the site of the old County Gaol Chaplain's House, No. 2 Ware Road, next to the Plough, in 1933. Provision was included for stage productions and an independent tea room with Lloyd Loom furniture and sometimes music, very Palm Court. After almost fifty years the cinema was closed in October 1982 and demolished in 1983. Now Yeomans Court and Graham House occupy its site.

HETFM 6037.129

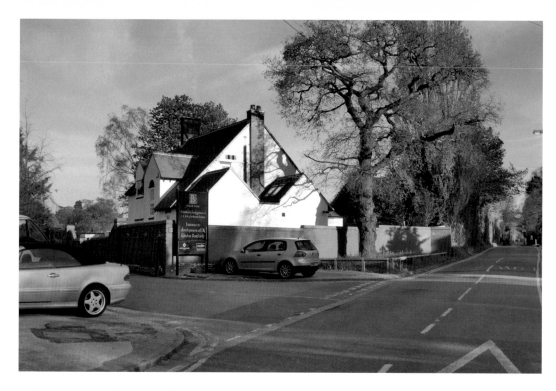

Balls Park Lodge, Mangrove Road

This is the White Lodge, as opposed to the Red Lodge, in London Road. It guards the back way into the park and to the mansion house from Mangrove Road, the principal entrance having imposing gates and leading in from the London Road.

HETFM 6205.277

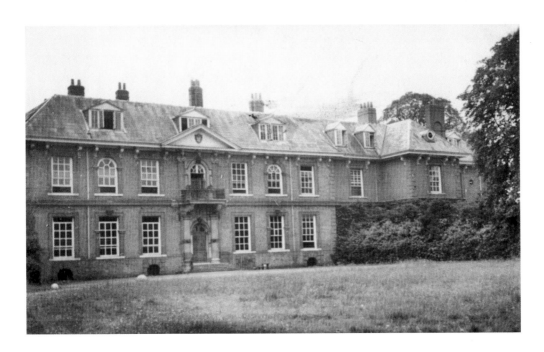

Balls Park

Balls Park was an important, ancient estate, the mansion being rebuilt by City merchant, John Harrison, *c.* 1637. It remained in the same family until the 1880s when George Faudel Phillips, Lord Mayor of London, leased and eventually purchased it. During the Second World War it was a children's home for LCC, and then purchased by HCC. After the war it became a teachers' training college, and then part of Hertfordshire University. It is now being converted into dwellings.

HETFM 6205.107

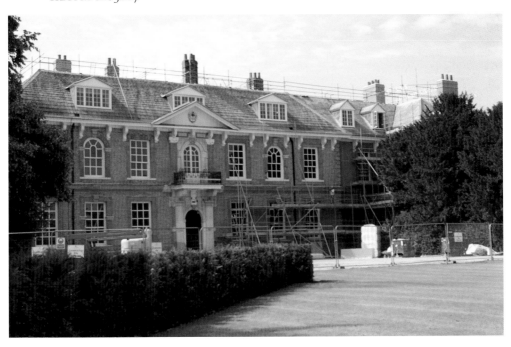

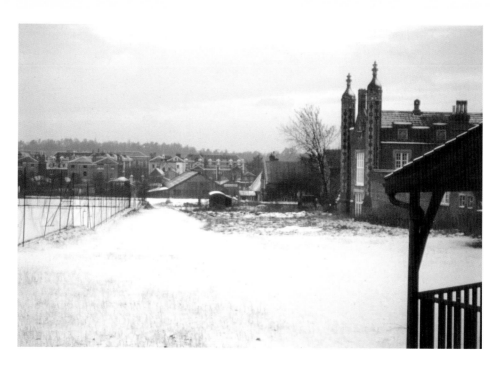

Tennis Courts and the Cowper School

Lots to spot in the 1960s shot. Extreme right, in the lower corner, is the edge of the Hertford Tennis Club Pavilion, and above, right, the west end of the Cowper School in London Road. The school yard wall is today the 'preserved' garden wall, in London Road, of these houses in Gwynnes Walk. The earlier photograph was taken nearer to the present day entrance to the Post Office Sorting Office on the site of the tennis courts, and beyond in the background, the rear of properties in Fore Street and some Christ's Hospital buildings.

PR 00258

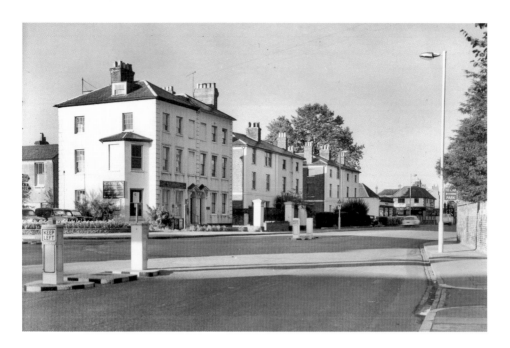

Houses opposite Christ's Hospital

To the right, in the foreground, is the entrance to Christ's Hospital. Immediately opposite the entrance, left of the picture, is London Road. In the 1760s the land, upon which these elegant houses were built, at the end of Fore Street, was owned by the family of the late Clerk of the Peace, Bostock Toller. A committee of the Quarter Sessions, looking for a site for the proposed Shire Hall in 1768, approached the Toller family, who'd already built the first block of two houses. Part of, but not the whole site was offered and the committee turned it down. It was later sold to Benjamin Rooke, who completed the row, and whose name was given to the already existing, nearby alley, which now runs up to Mangrove Road. The houses were demolished in the 1960s for the relief road.

HETFM 6205.138

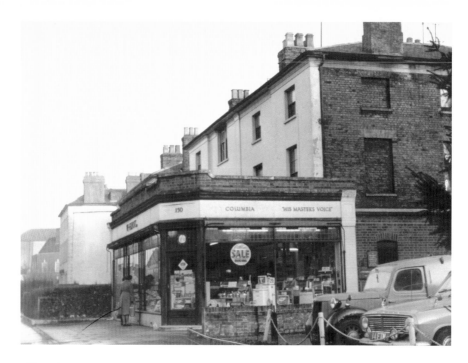

Elliotts', 150 Fore Street

Elliotts' Music Shop is appropriately built on the site of a small nineteenth-century concert hall belonging to musician, teacher, and Ware organist, Thomas William Luppino, who lived next door from the 1820s to 1857. Private concerts and dramatic performances were given there during his lifetime but the building was taken down after he died. A later occupant of the house was Revd Harry Evans who sold it to the Post Office in 1950.

 HETFM 6254.37

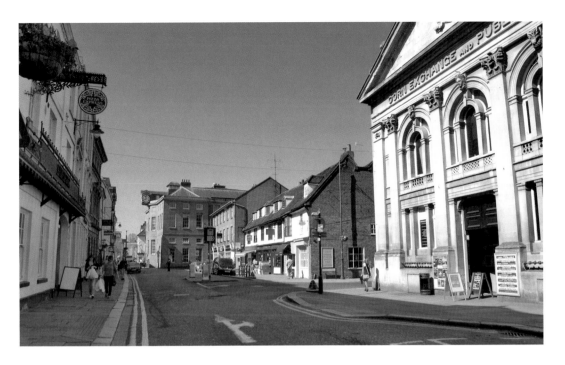

Fore Street

This print dates from 1821, three years before the appearance of John Briant's Shire Hall Clock. From the right: the Cross Keys (rebuilt 1864), and the Butchers' Market, now the Corn Exchange. There was no Market Street until 1890, then most of the buildings we still have, include oddly prolific and misaligned dormer windows. On the left, the Half Moon became the Dimsdale and the gabled building with open casement became the Post Office.

Hrt Mus WDB 164901

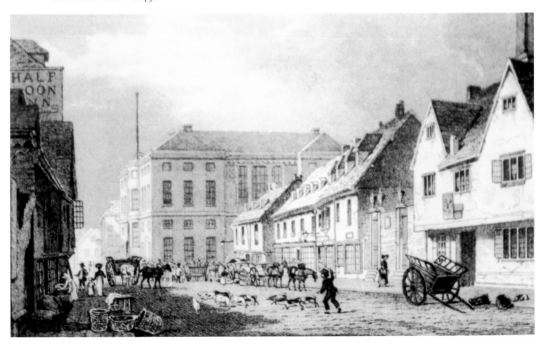

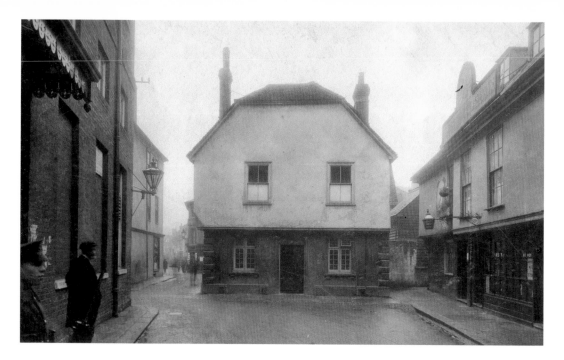

The Vine Inn

The Vine Inn in Market Place, now Salisbury Square, came down in 1925, but with its rear companion, the Red Cow, was de-licensed earlier and used for other purposes. It was said to be here, that highwayman Dick Turpin was spotted by the authorities, and made a successful getaway. The two inns' removal must have been a boon to the hemmed-in White Hart.

HETFM 6036.174

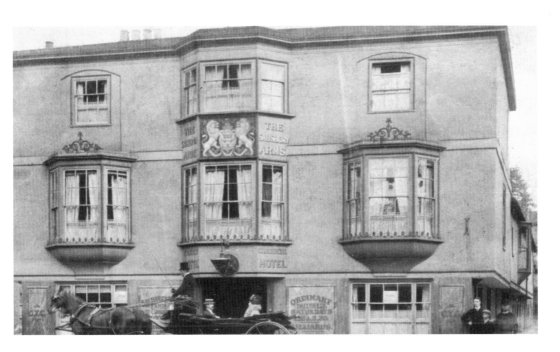

The Salisbury

The Salisbury Arms was the Bell until 1820, named after the Market Bell, which hung in Market Place. The date of 1570, on the front elevation, may indicate the time of it becoming an inn. Before that, it was owned by a wealthy draper, John Ferrar, and could have been both his home and business premises. The large gates in both Bell Lane and Church Street were wagon ways into the courtyard, the structure of which can still be seen from inside.

HETFM 2832.869

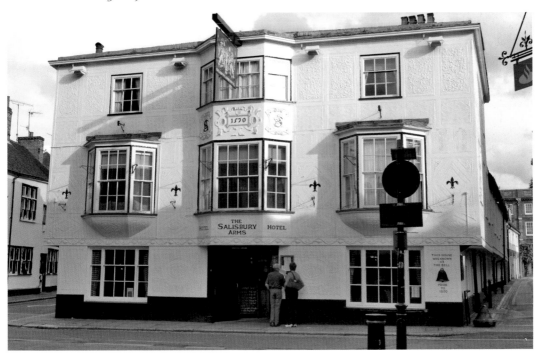

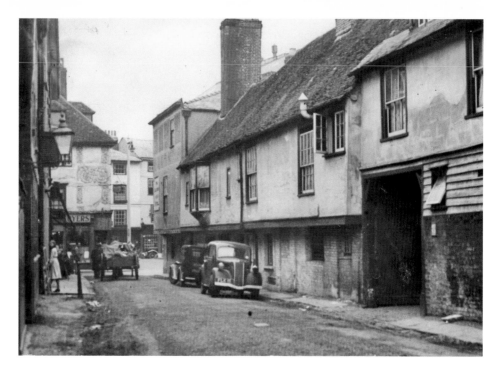

Bell Lane looking towards Market Place

This photograph is from the 1930s. The corner of Fore Street shows the pargeting which will be referred to later. Right, is the Salisbury Arms and left, the premises, which in the nineteenth century belonged to Nunn's, the ironmonger's, whose key sign, dated 1798, now hangs outside Hertford Museum. Manufactory House, now restored, was Nunn's workshop and lies behind the premises in Bell Lane. Milletts now occupy the shop.

HETFM 6037.278

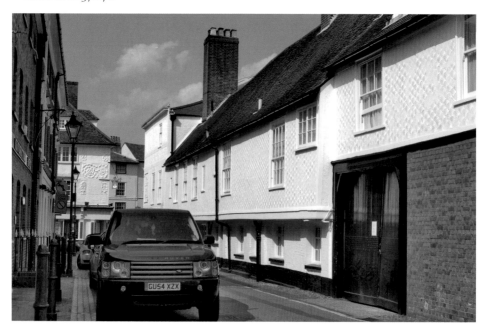

Fire at Market Place

Botsford and Wightman's shop in Market Place was destroyed by fire, which started before noon on Valentine's Day, 1940. Macfarlane's dress and hat shop next door was also badly damaged and both properties had to be rebuilt. They were originally one, the King's or Queen's Arms (as monarchs succeeded), an inn bought and refurbished by Dr John Dimsdale, *c.* 1706. There was an elegant staircase in Botsford's which is dated 1713. East Herts Electrical and Inter Sports occupy the site today. The gas lamp on the left of the picture is mounted on the wall of the Shire Hall and Honey Lane goes off to the right. The figure, bottom right, is Fred Roche, the shoe repairer, and father of Eddie.

HETFM 6037.259

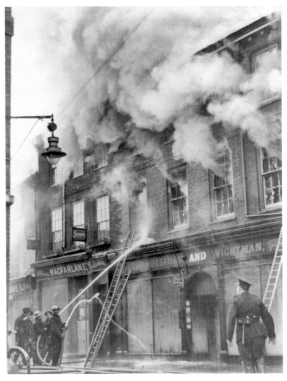

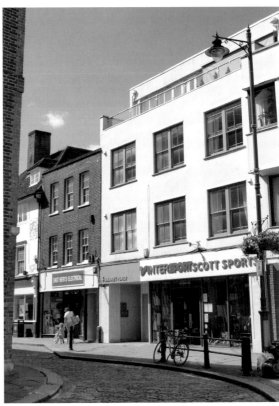

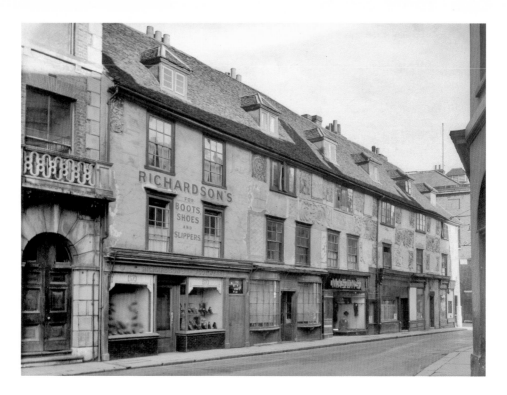

Richardsons, Fore Street

This block, 3–13 Fore Street, which may have been one house or several terraced dwellings, shows the skill of the pargeter in its Renaissance foliage motifs. Historians' opinions of the building's age differ between late 1500s and late 1600s. If, as some suggest, it was built to accommodate government escapees from pestilence in London, it would need to be of the earlier date. Surprisingly, for the period it is not jettied, i.e. overhanging the street. The earliest shop front is probably with the bow windows at No. 5, approximately in the centre of the picture. Richardsons, at No. 3, was the shoe shop, as some readers may recall.

HETFM 6205.36

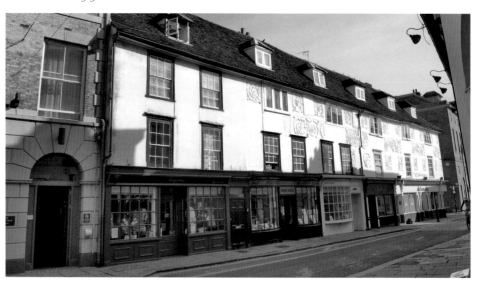

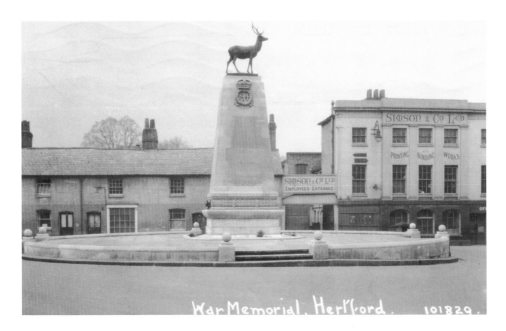

War Memorial, Hertford. 101829.

The War Memorial

Parliament Square was so named in 1921, when Hertford's War Memorial, commemorating the fallen of the First World War, was built. A triangle of old buildings had occupied the space but were purchased by Sir Edward Pearson of Brickendonbury, and presented to the Corporation. Shopkeepers and tenants were relocated, and the site razed. The memorial was designed by Sir Aston Webb, and the sculpture cast by Alfred Drury. Andrews, stonemasons from Ware Road, completed building work. The names of Second World War heroes were added in 1947. The cottages seen behind were formerly called Parliament Row, and are now replaced by modern buildings.

HETFM 1988.2.1

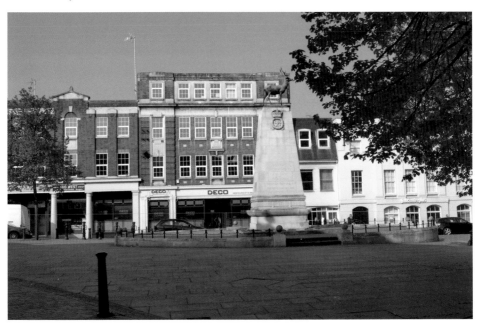

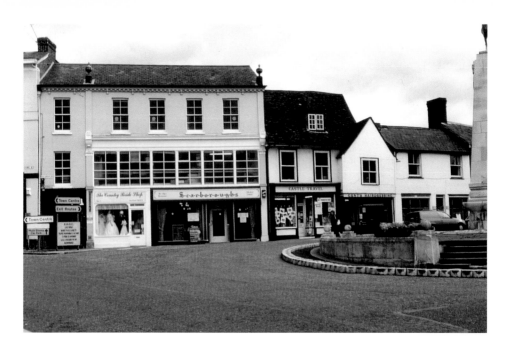

Scarborough's, Parliament Square

Castle Travel and Ivan Watkins' Gents' Hairdressing Salon occupy the ground floors of a very important building. It is a possible hall house and a further example is at No. 1, St Andrew Street. In this 1970s shot, Scarborough's and the Country Bride Shop occupy premises which had earlier served as a garage and petrol pump facility. In the first floor windows, as at Waters' in North Crescent, London, to Brighton type cars, and horse-drawn carriages at Waters' (McMullen's then), were displayed. It is said that, although not the first of the nation's roundabouts, the War Memorial was the first to develop the rule of the road on roundabouts to 'give way to traffic from the right'.

PR00433

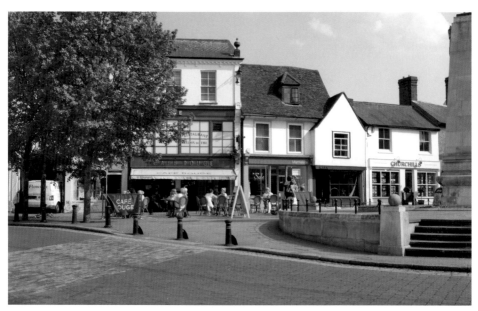

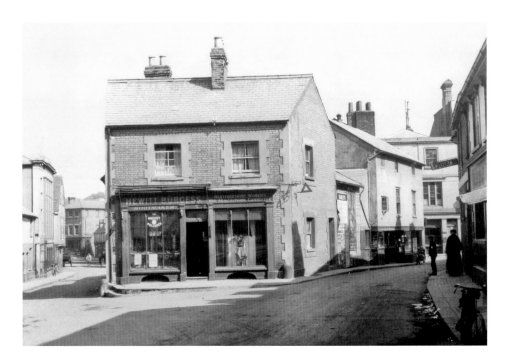

Hewitt Burgess, later Parliament Square

Ebenezer Hewitt's boot store and its neighbour, Hertford Branch Women's War Agriculture Committee, faced south towards Castle Street and the way towards Essendon via Hornsmill. This cluster of shops was taken down for the War Memorial. The dismantling of property here was not completed in time for the first Remembrance Ceremony on 6 November 1921 and huge Union Jacks were used to cover Mr Nightingale's barber's shop, at the Wash end as he was the last to be found other accommodation. He eventually took premises near the Green Dragon Vaults.

Hrt Mus WDB 093501

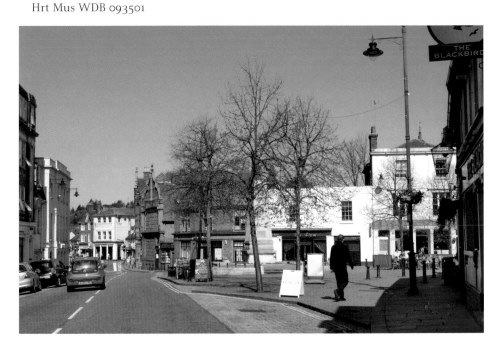

At the Bottom of Queen's Road

Still a handy 'free on-street' parking spot today, No. 1 Queen's Road on the left (now Allaway Accoustics) was Hertford Police Station before its move over into Castle Street. This portion of Queens Road skirted Bayley Hall (off picture on the left), and All Saints' Churchyard. Queen's Road hill turned right, just where the fence of the Nut Walk and other grand houses stops.

PR00978

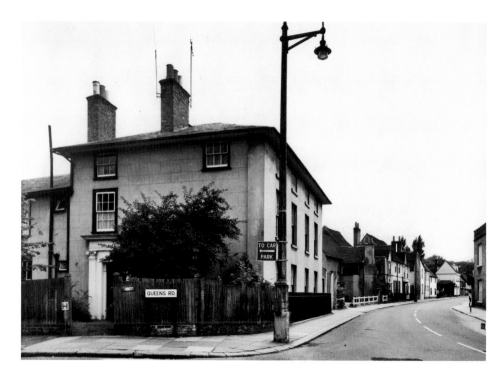

Corner of Queen's Road and Castle Street

No. 19 Castle Street became No. 2 Queen's Road. Called 'Green Gates', it was the home of George Nicholson, a solicitor from before 1820. In 1824, it also became his place of work, when he and partner Philip Longmore moved from St Andrew Street to an older wing at the back of No. 19. The house was rented from the Nobles Charity, endowed by Thomas Noble in 1663. By 1834 the firm, which became Longmores, had moved across the road to their present premises.

HETFM 6402.1.58

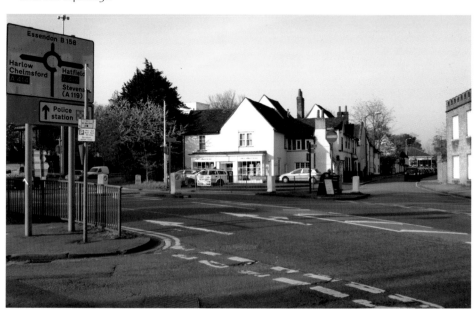

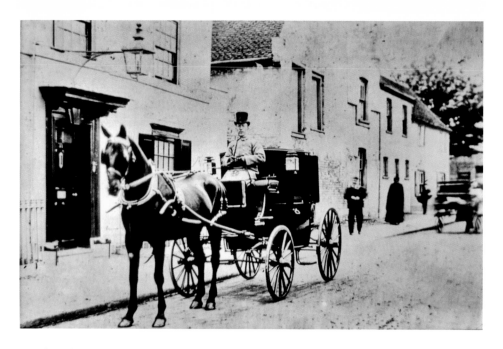

Coach and Horse, Castle Street

Dr Odell's coachman, Mr Storey, is waiting outside the doctor's house, No. 23 Castle Street, about 1900. The picture was provided to Hertford Oral History Group when his 102-year-old daughter, Annie Inman, made her recording some years ago. As can be seen, the fine hall house, and its neighbour which is now the home of Mr and Mrs Jim Thornton (and earlier of the Andrews family, who founded Hertford Museum), both remain unchanged, including the barn loft doors!

PR00124

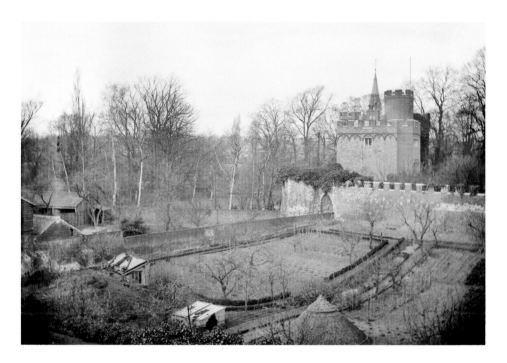

Castle Moat Garden

The idea of opening the castle's remaining stretch of dry moat to the public came from Cllr Robert Addis. This involved lowering the high brick wall, which once shut out rented cottage gardens from Castle Street. The postern gateway in the garden of No. 36 was kindly presented to the town. An eighteenth-century ice-house, thought at first to be an air-raid shelter, was identified. Castle Moat Garden was grassed and planted and opened to the public in 1951.

HETFM 2008.58.415

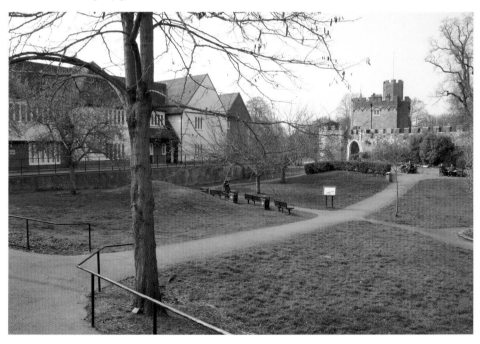

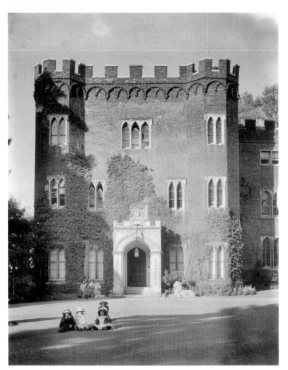

Castle Gatehouse

A view of Hertford Castle's west front taken in about 1910, just before it became the Borough Council's offices. The small north wing was not built until 1937. In its heyday of the 1790s, the castle had two impressive flanking wings, one of which was demolished in 1820, while the other, which remains, was shortened by one bay.

HETFM 6037.444

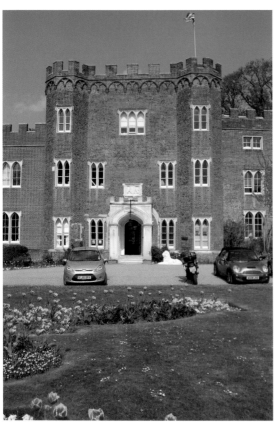

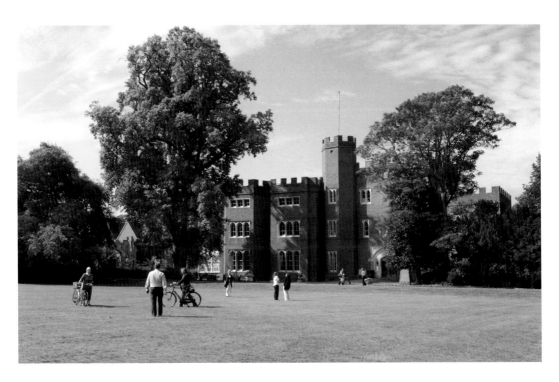

Anyone for Tennis?

After the Borough Council's tenancy of Hertford Castle, the grounds were opened to the public in 1912 and tennis courts occupied the east lawn. There had been more ambitious plans, perhaps a mini Vauxhall or Ranelagh, but the proposed increases to pay for it were rejected by the ratepayers. This picture dates from 1913.

HETFM 2832.597

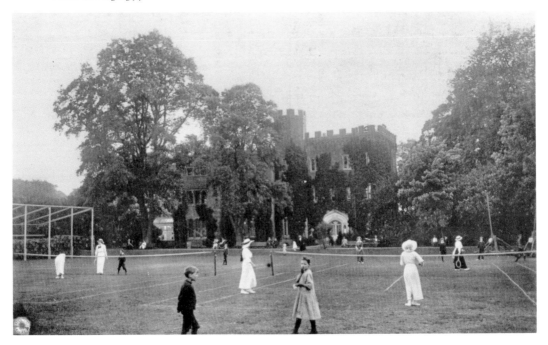

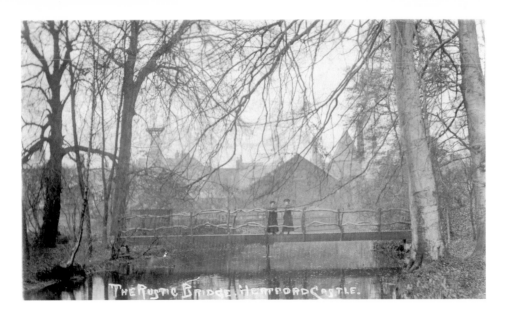

Rustic Bridge, Castle Grounds

The picture of 1905 shows the rustic bridge spanning the Lea in the same position as today's, which links the castle grounds via a second bridge to the St Andrew Street car park. The background is different though, tall brewery chimneys and malting cowls reminding us of the town's principal industry. The castle grounds were not open to the public until 1912 so presumably, the bridge strollers were connected with the castle, then a private house.

HETFM 2832.660

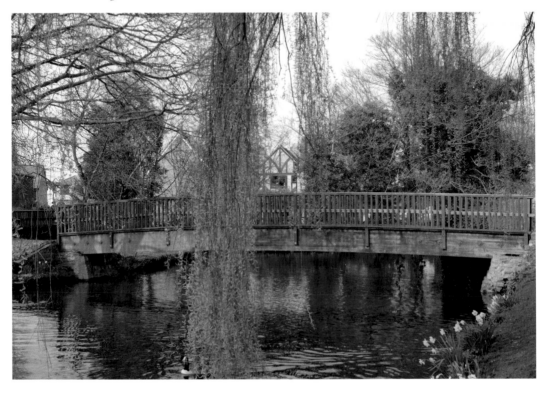

Between Numbers 25 and 29 Castle Street

This is where the underpass now descends and where there was once the office and carpenters' shop of R. T. Andrews, architect and builder, and whose family had occupied No. 25 for generations. With his brother, W. F. Andrews, of No. 27 West Street, R. T. Andrews founded Hertford Museum in 1903, at No. 56 Fore Street, moving to Bull Plain in 1914.

Hrt Mus MSS 041101

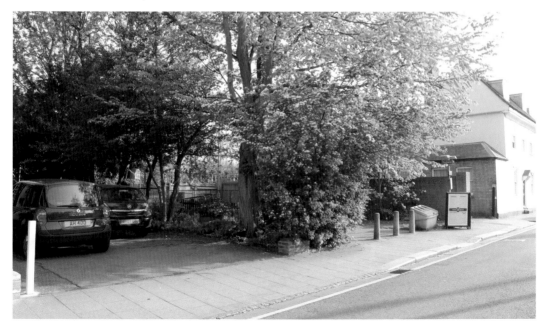

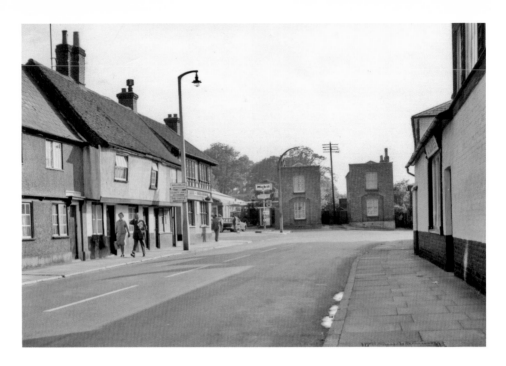

The Castle Street Bend

Before the Gascoyne Way, Castle Street, led by a dog's hind leg route into West Street. The vehicular gate into the castle was sharp right just out of the picture. Behind the nearer lamp post is the Gladstone Arms, on the corner of concealed Pegs Lane, which in turn, led up to County Hall. Beyond the Gladstone is Chaseside Motors, last in a line of wheelwrights, coachworks and garages on this same spot. Today, on the opposite side of the relief road, Gates continues the tradition. Ahead are two cuboid houses, looking like bookends, which were built by Jesse Poor, of West Street about 1817, in the grounds of a small mansion, Pimlico House, demolished in the early 1800s.

HETFM 1993.12.1.38

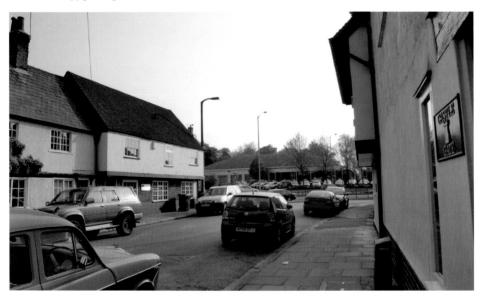

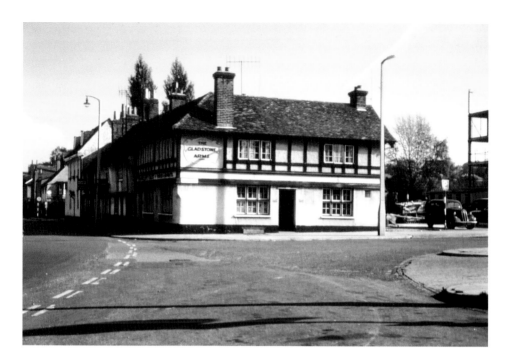

Corner of Pegs Lane and Castle Street
There wasn't room for the Gladstone Arms as the ghastly relief road, Gascoyne Way, swept through, although the more ancient White Horse of Nicholls' Brewery did survive. The skeleton of the equally unwelcome Sovereign House with its huge safe bunker, below, is just appearing.
 PR00211

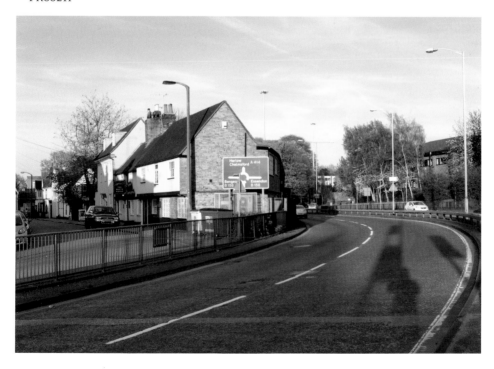

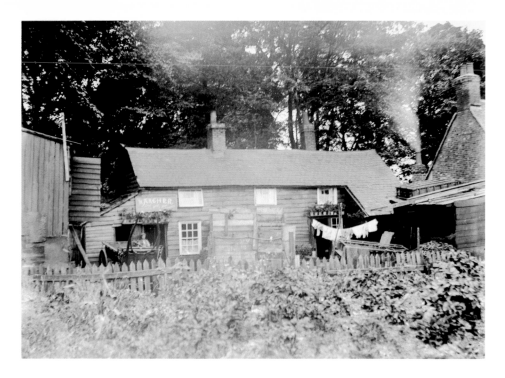

Archer, of Pegs Lane

Pegs Lane, as it left Castle Street to join today's Bullocks Lane, was a closely populated area with at least sixteen old cottages, and minor industry, straggling down the hill before the 1930s. An example is the Archers' blend of rustic domesticity and workshop, with supporting ramshackle sheds and loaded washing line. This may be W. J. Archer, the last resident before total clearance to form the uncluttered approach to the new County Hall. He is listed as a 'marine dealer' in the 1940 trade directory.

Hrt Mus An 111111

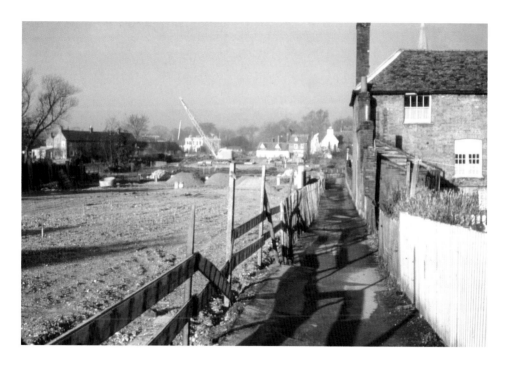

Water Lane and Gascoyne Way

More evidence of the damage to our tightly built ancient town! Both pictures show the scar made by Gascoyne Way. Here, we look past the now saved (but unhappily overpowered), ancient Water Lane Castle Cottages towards St Andrew Street, and a few ancient buildings, which also survived. The row on the left of the older picture is Hattam's Yard (see page 21) houses – on the site of what was formerly known as Creaseys of Hertford. The wash houses with the copper wash tub chimneys of No. 10 and No. 12 Water Lane have also been lost.

PR00073

Gentlemen's Toilet, Water Lane
The ancient brick wall at the side of
Water Lane, enclosing the cottage
garden of Mr Geeves, the organ blower
at St Andrew's, has been substituted
for a close boarded fence, ivy covered.
Gone, too, is the 'Gents' Only' urinal,
which shared a gas lamp with
passers-by in Water Lane. The roof of
Mr and Mrs Geeves' end-of-the-garden
lavatory can also be seen in the
older shot.
 HETFM 6254.199

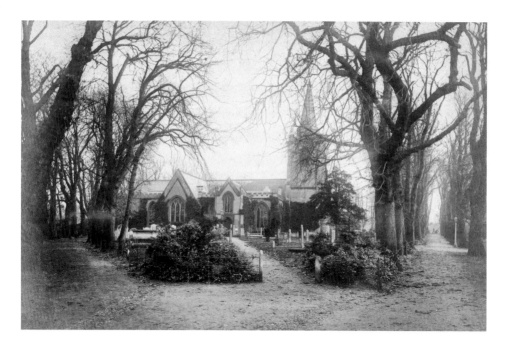

All Saints' Church

The church had an ancient foundation, twelfth century or earlier. In 1640 its parish was united with the church of St John, which closed, once part of Hertford Priory, and now commemorated in Priory Street and St John's Street. One vicar cared for the needs of both parishes. In association with All Saints, the Hertford College Youths' Ringing Society was established in 1767, and bell-ringing became very popular in the town. In December 1891, a disastrous fire seized the old All Saints Church and it was completely destroyed. Re-building quickly began and it was reopened in 1895 without a tower, which eventually came in 1905, and the new bells in 1907. In the 1960s, the Gascoyne Way ploughed through the front of the churchyard, cutting off the church from the town and disturbing many graves.

HETFM 6331.1

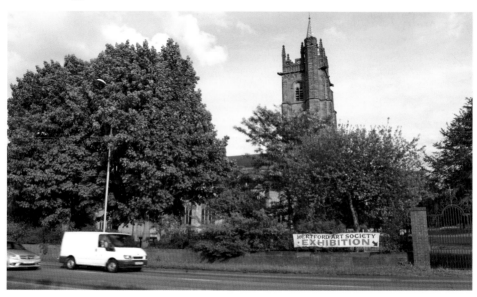

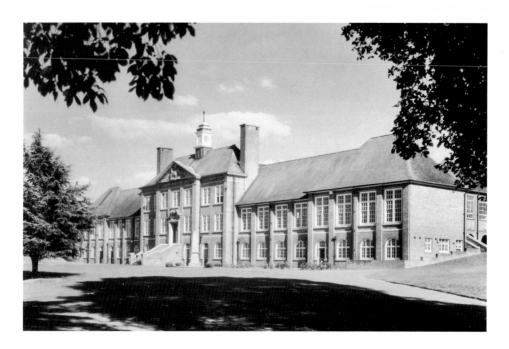

Richard Hale School, from Pegs Lane

This building was opened in 1930. The former premises were in Churchfields. Richard Hale, a City merchant, founded the school in 1617 and it later had a boarding department in the Master's House, Fore Street. The school today enjoys a reputation for producing 'men of the cloth', including the present Bishop of London, the Right Reverend Richard Chartres. Before the construction of Gascoyne Way, Wesley Avenue led up from Castle Street. 'Wesley' because John Wesley, the founder of Wesleyan Methodism, had several times stayed at No. 25 Castle Street by the avenue's entrance. Today the underpass to the school follows the same route. (Photograph from the collection of Peter Ruffles, by George Blake, town photographer post Second World War, his Prefect's Leaving Prize.)

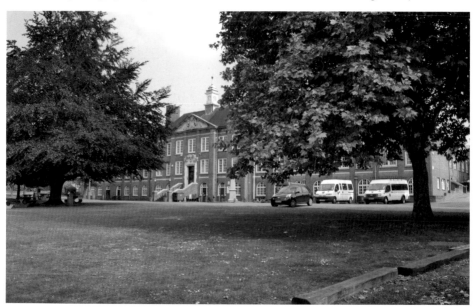

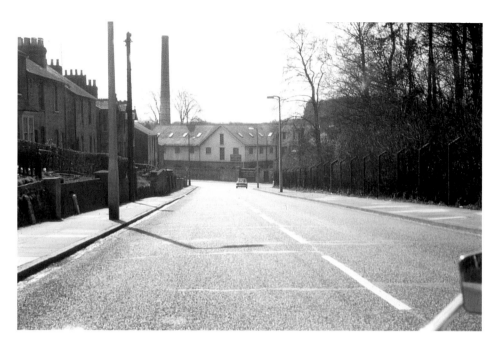

Horns Mill Factory

Social change is evident here. A modern car driver would be unlikely to risk taking a shot while driving down Bullocks Lane – but the road was less hazardous when Bullocks Lane domestic parking needs were fewer! Webb's leather dressing factory was a modern tannery and initially prepared chamois and sheepskin, but soon added buckskin and reindeer skins to their repertoire. The 'Hertford Lammie' gloves were their most famous products, but they also made breeches for the Household Cavalry and First World War trench jerkins and flying jackets. The factory closed in the early 1970s and was developed for housing.

PR00109

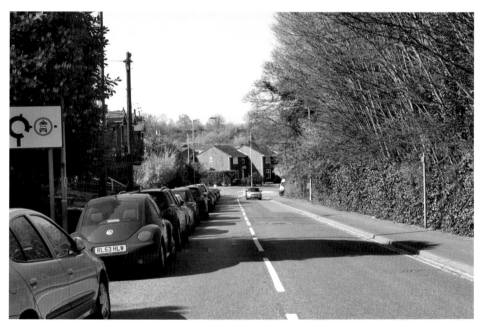

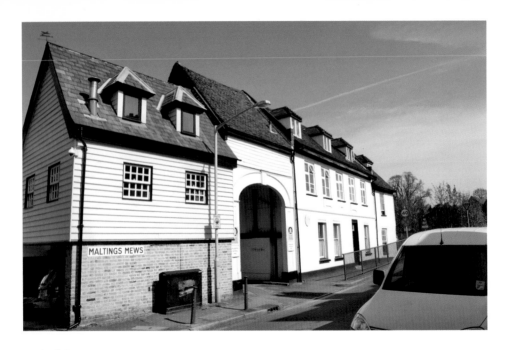

Nicholls' Brewery, West Street

This is Nicholls Brewery House, the brewery is behind it. Its chimney can just be seen on the left. On the extreme right is the Black Swan, now under Gascoyne Way. The former brewery tap was called the Oddfellows' Arms. The loss of the lofty, ancient chimney stack and the yester-year construction in the left foreground are to be regretted, but these final shots on our town tour are appropriate to end with – illustrating as they do, our characteristic dormer windows, and importantly, an enduring connection with the town's principal industry, close to an essential water supply (the Lea, here), malting and brewing.

HETFM 6402.1.54

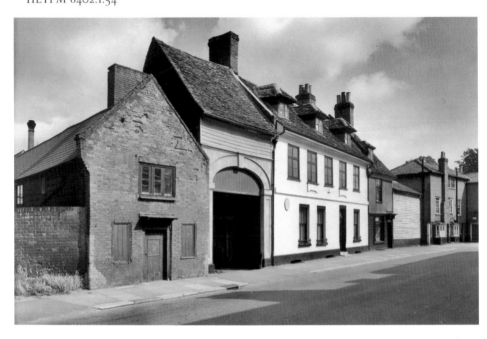